IMAGES of America
SAN BERNARDINO FIRE DEPARTMENT

History of San Bernardino
Prior to 1865

1847: A party of the Mormon Battalion is sent to establish a military post at Cajon Pass to protect valley ranches from rumored attack by American Indians.

1848: Captain Jefferson Hunt, a battalion leader, returns to Salt Lake City and leads a group of men back to the San Bernardino Valley to pick up supplies. Hunt sets up headquarters at Chino Rancho, owned by Isaac Williams.

1851: Under Brigham Young's directive, Andrew Lytle leads a wagon train of settlers 400 miles from Utah to San Bernardino. The Mormons buy the 35,000-acre San Bernardino Rancho for $77,500. Worried about an attack by American Indians, they build a fort at the site of the present-day courthouse at Third and Arrowhead.

1852: About 100 Mormon men from the San Bernardino settlement build a logging road up Twin Creek Canyon in 10 days. They also build a sawmill, supplying lumber to build 700 houses in another small, but growing community—Los Angeles. Also in 1852, the gristmill is built.

1853: Jefferson Hunt becomes the first area representative in the new California Legislature. He sponsors a bill to create the new County of San Bernardino, splitting away from Los Angeles, and it passes. Settlers, having made friends with the American Indians, leave the fort for new homes they have built. The town site of San Bernardino is laid out, and the Mormon Council House is built.

1854: The City of San Bernardino is incorporated as a city and the new county seat. Amassa Lyman becomes the first mayor. Stagecoach service is established between San Bernardino and Los Angeles.

1855: The city purchases six school lots from grant owners.

1856: Over 3,000 Mormon men, women, and children occupy the city. New settlers arrive weekly from Utah. Disputes over land cause bad blood between Mormons and the people who have split from the church, known as dissenters or "independents."

1857: Brigham Young orders Mormons to pull up stakes in San Bernardino and return to Utah. He says men are needed as reinforcements because the Utah Mormons are under threat of attack from the U.S. Army as the anti-Mormon settlement swelled. In reality, Young feared some Mormons in San Bernardino would allow outsiders to influence them and become unfaithful. About 2,000 people leave and about 1,000 stay.

1858: Butterfield stage route is established.

1860: Gold is discovered in Bear and Holcomb Valleys. The first newspaper in the county is established—the *San Bernardino Herald*.

1861: A toll road through Cajon Pass is established.

1862: The first orange grove (four acres) in San Bernardino is started.

IMAGES of America
SAN BERNARDINO
FIRE DEPARTMENT

Steven Shaw

Copyright © 2003 by Steven Shaw.
ISBN 0-7385-2851-X

Published by Arcadia Publishing,
an imprint of Tempus Publishing, Inc.
Charleston SC, Chicago, Portsmouth NH,
San Francisco

Printed in Great Britain.

Library of Congress Catalog Card Number: 2003108756

For all general information contact Arcadia Publishing at:
Telephone 843-853-2070
Fax 843-853-0044
E-Mail sales@arcadiapublishing.com
For customer service and orders:
Toll-Free 1-888-313-2665

Visit us on the internet at http://www.arcadiapublishing.com

In the 1860s San Bernardino was a typical "wild west" town, and the wooden buildings standing very close to one another were a conflagration waiting to happen. Early history tells us very little about any events that led up to the organization of a fire department in San Bernardino, but in 1865, citizens took action to make their new city a safer one.

CONTENTS

Acknowledgments 6

Introduction 7

1. The Beginning, 1878–1889 9

2. Reorganization, 1889–1909 15

3. Dawn of Motorized Era, 1910–1939 41

4. Modernization, 1940–2003 63

5. Restoration, 1997 to the Future 119

Acknowledgments

This book would not have been possible without the interest in and dedication to history of three men. Dwight Littleton, former fire chief, and Sieger Pruiksma, former assistant chief, personally collected photos, badges, and books. They passed them down to my father, former chief Raymond Shaw, who in turn passed them down to me. My father and mother understood the importance of history, and they both inspired me with an interest and desire to preserve the past.

I also dedicate this book to my children, Kelly and Mike, and my loving wife, Gail, who has supported my passion for collecting through the years.

INTRODUCTION

Fire protection in San Bernardino actually had its origin June 22, 1865, from a meeting held in the Pines Hotel. Four days later the first fire company was organized with the appointment of William McDonald, foreman; Nathan Kinman, first assistant; Aubrey Wolf, second assistant; and I.H. Levy, secretary-treasurer.

A concert was held to raise funds to purchase needed fire-fighting equipment. The equipment was purchased with $103 collected from the concert and consisted of 4 ladders, 4 axes, 4 hooks, 24 buckets, a fire bell, and a speaking trumpet.

Third Street, at the foot of "C" Street (now known as Arrowhead) was the site selected on which to erect San Bernardino's first fire station. The company was in existence until 1871 when the property was sold. The money from the sale of the property was placed in the trust of M.H. Suverkrup, to be invested for the benefit of the company.

No explanation has been found as to why the organization broke up. The growing city was without fire protection. In 1878, several disastrous fires occurred. The fires consumed entire city blocks and burned out businesses such as John McCall's Blacksmith Shop, R.I. Task's fruit store, offices of Dr. Rene Campbell and Justice Morse, the Boston Bakery, and the Lone Star Saloon.

On October 3, 1878, a meeting of the members of the old Fire Company was called and the San Bernardino Fire Department was organized. The funds of the old company were turned over and William McDonald was again chosen as foreman. He was San Bernardino's first fire chief.

With the assistance of the citizens and town trustees, a hand-pump fire engine, and a horse cart were purchased. Mike Hayden became foreman of the "Pioneer Hose Company". Uniforms were adopted for them and the "Pioneer Engine Company." The first trial of the new apparatus was described in the *San Bernardino Daily Times* as follows:

"At 15 minutes to one o'clock on January 17, 1879, the alarm sounded for the gathering of members. At 1 o'clock sharp the firemen fell into line and headed by the San Bernardino Cornet Band, marched down "D" Street to Fourth Street, then east to Matthews' Mill. There the engine took water from the mill flume, throwing two splendid streams both horizontally and perpendicularly. The order to 'take up' was given and the Company fell into line and proceeded to the tank of Van Dorin & Lehman where the 'little' institution got on her muscle, throwing a solid stream fully 20 feet above the front of the Odd Fellows Hall. 'Take Up' again was the order and headed by the band under the instruction of John Andreson, the Company was conducted to his place of business, Third and "E" Street, where a 'baptismal ceremony' took place."

The city was growing rapidly. San Bernardino had an Opera House before Los Angeles did

and attracted the like of Lillie Langtry as well as other acts. The first transcontinental train came into the city in 1885. In 1887, the Stewart Hotel was built. At four stories and 150 feet square it was at the time the finest hotel structure south of San Francisco.

The city's fire department grew right along with it. In 1889, it was reorganized by Chief David Wixom and became part-paid instead of the all-volunteer department it was. It soon had a horse-drawn steam pumper and ladder truck. San Bernardino has always had an excellent water supply. In 1890, $150,000 was spent to have the system joined together with mains and hydrants throughout the city. The gravity fed system gave it excellent pressure.

In 1911, the first motorized fire apparatus was purchased. The number of motorized apparatus grew rapidly to replace all the horse-drawn equipment.

In 1926, there were four fire stations. The number grew to ten stations in the 1960s. Paramedic Service was added in the 1970s. And today, there are two Battalion Chief vehicles, two ladder trucks, a Hazardous Materials vehicle, a Heavey Rescue vehicle, an Air Supply vehicle, two Water-Tenders, five Brush Engines, and twelve Paramedic Engine Companies.

October 3, 2003 marks the 125th anniversary of the San Bernardino Fire Department.

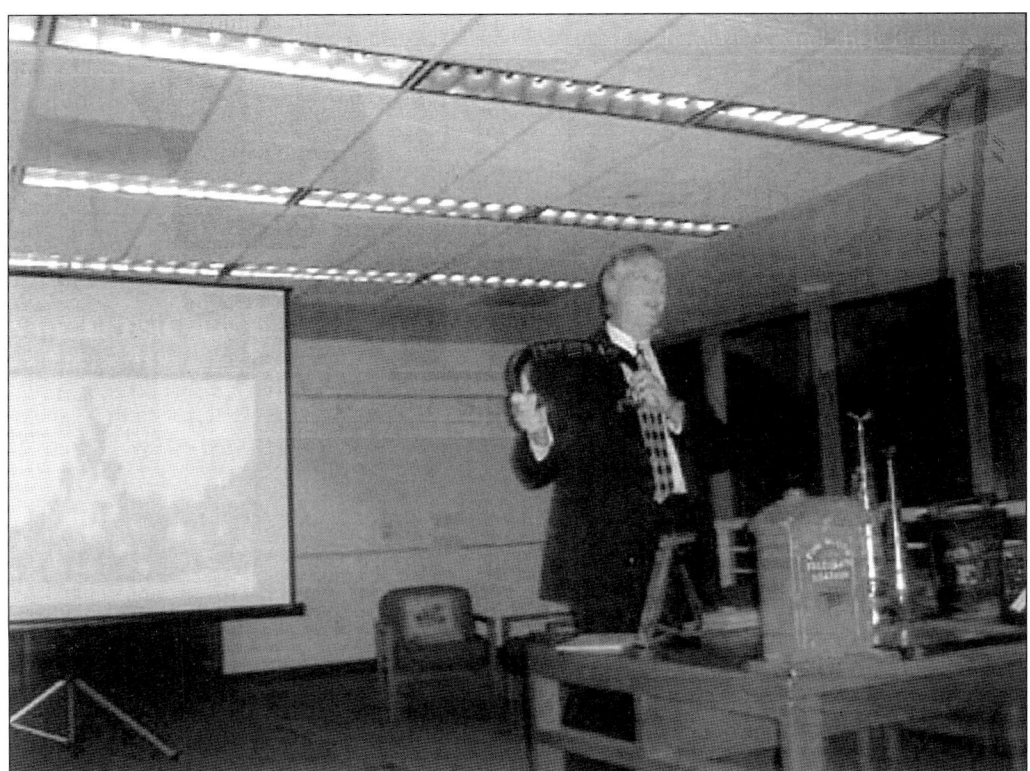

The author, Steven Shaw, makes a presentation on the history of the San Bernardino Fire Department at California State University, San Bernardino, in May 2001.

One
THE BEGINNING
1878–1890

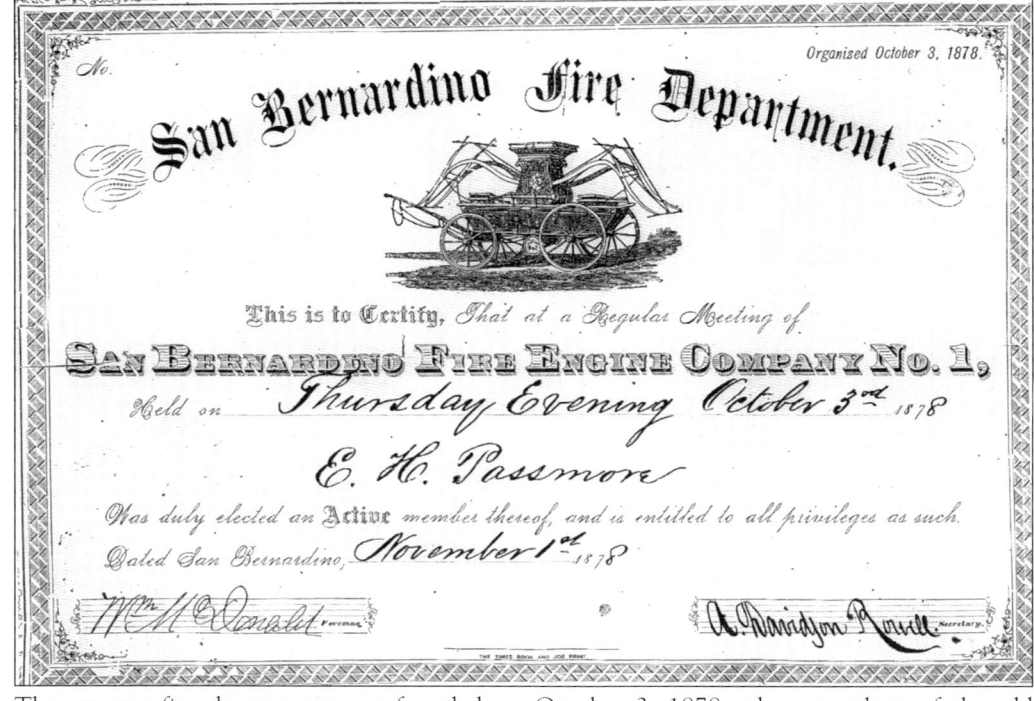

The present fire department was founded on October 3, 1878, when members of the old company formed a volunteer company. It was funded by the sale of property and equipment from the previous company in 1871. Membership certificates like this one for E.H. Passmore were issued to everyone in the organization. The following men were its new officers: William McDonald, foreman; Raymond Woodword, first assistant; J.W. Morgan, second assistant; A.D. Rowell, secretary; and C.F. Roe, financial secretary.

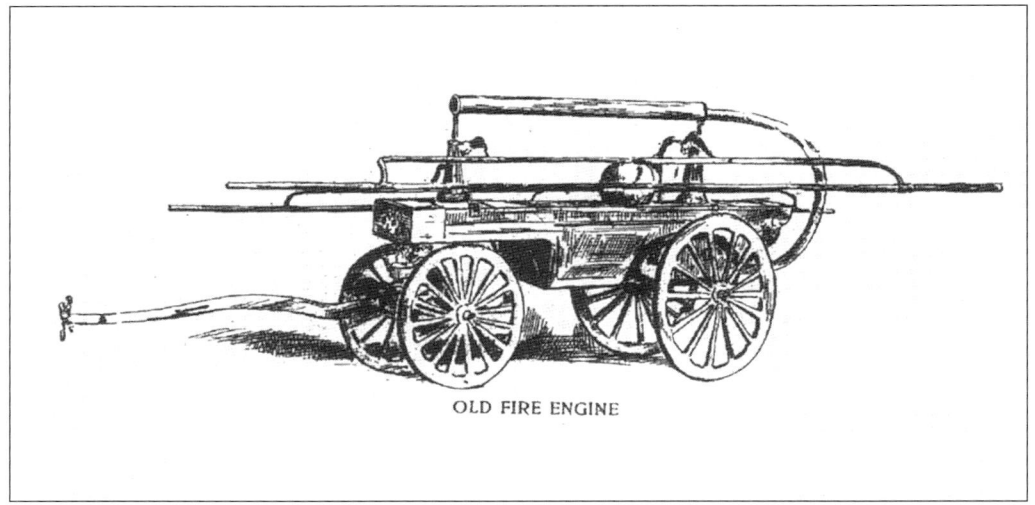

OLD FIRE ENGINE

With the help of the town trustees and citizens, the first engine company was formed. Pioneer Engine Company #1 consisted of a 246 piano engine (a hand pumper) capable of supplying two hose streams. At this time, a hose cart was also purchased and the Pioneer Hose Company #1 formed with M. Hayden as its foreman.

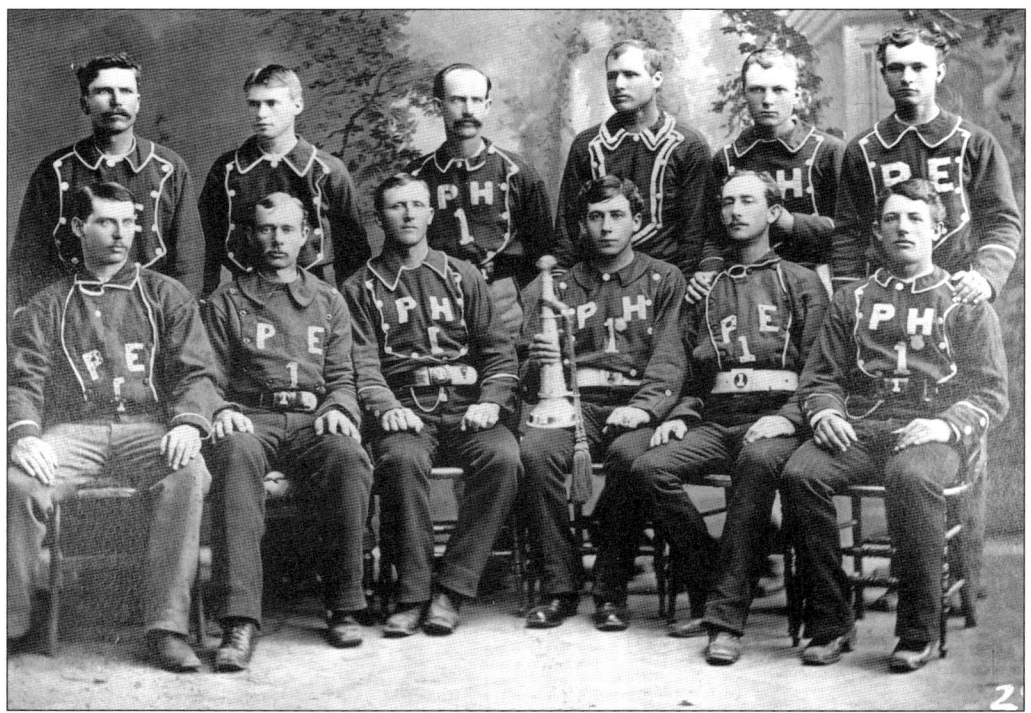

Uniforms were adopted for the first time by San Bernardino Fire Department personnel in 1879. The men with "PE1" on their shirts are members of Pioneer Engine Company #1, while those with "PH1" on their shirts are members of Pioneer Hose Company #1. Several future fire chiefs appear in this photograph, including Al Glatz, seated on the far left. Glatz was later appointed driver of the hose wagon and served for five decades before retiring as chief.

Pioneer Hose Company #1 was formed in 1878. An unknown maker built this very ornate hose cart, which was originally used with the hand pumper, then used with the steam pumper in 1884. A rope extended from the handle allowing more men to pull it through the dirt streets.

The Ahrens Company built this hose cart in 1878, and it was used by Pioneer Hose Company #2. In 1978, the cart was found in a vacant field and has since been fully restored. It has now appeared in many parades.

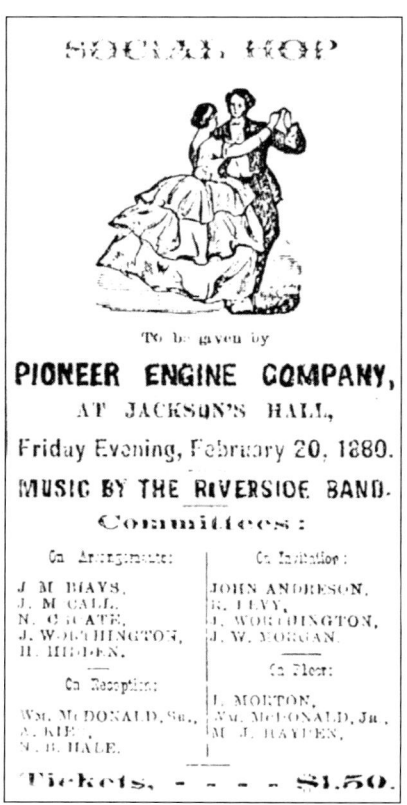

The "fire laddies" took an active part in the social life of the community, as they did in all small communities at that time. No celebration was considered complete without an exhibition by the "fire boys," and the annual ball for their benefit was one of the social events of the year.

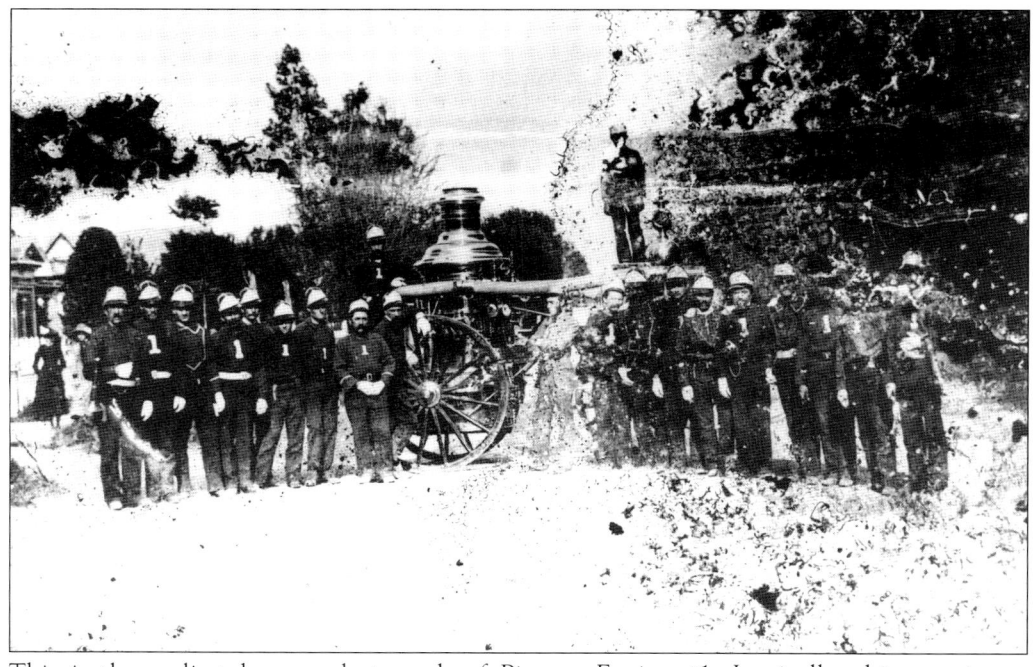

This is the earliest known photograph of Pioneer Engine #1. Ironically, this rare image sustained water damage when the log cabin of the San Bernardino Society of California Pioneers caught fire in 1972.

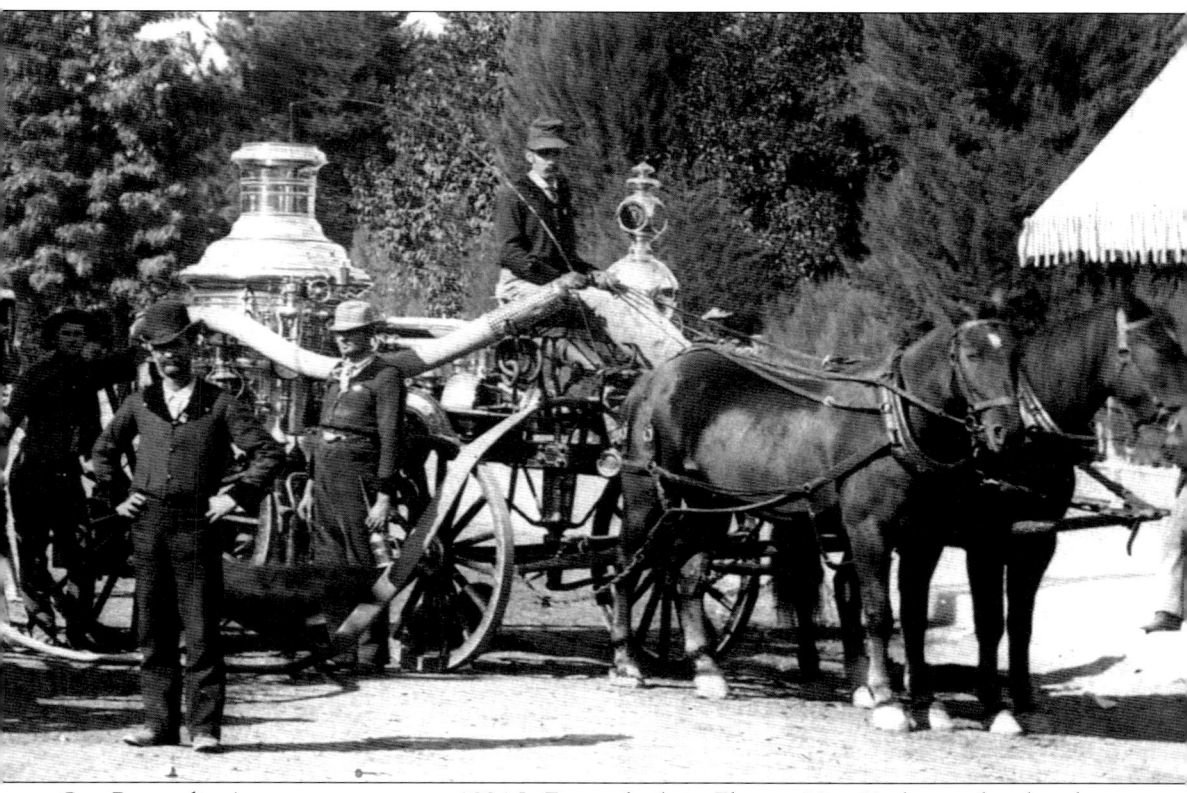

San Bernardino's steam pumper, an 1884 LaFrance built in Elmyra, New York, was first hand drawn and then became horse drawn. It was made nearly obsolete when a high-pressure, gravity-fed water system was installed throughout the city. The whereabouts of this very ornate steam engine are unknown; it was likely scrapped.

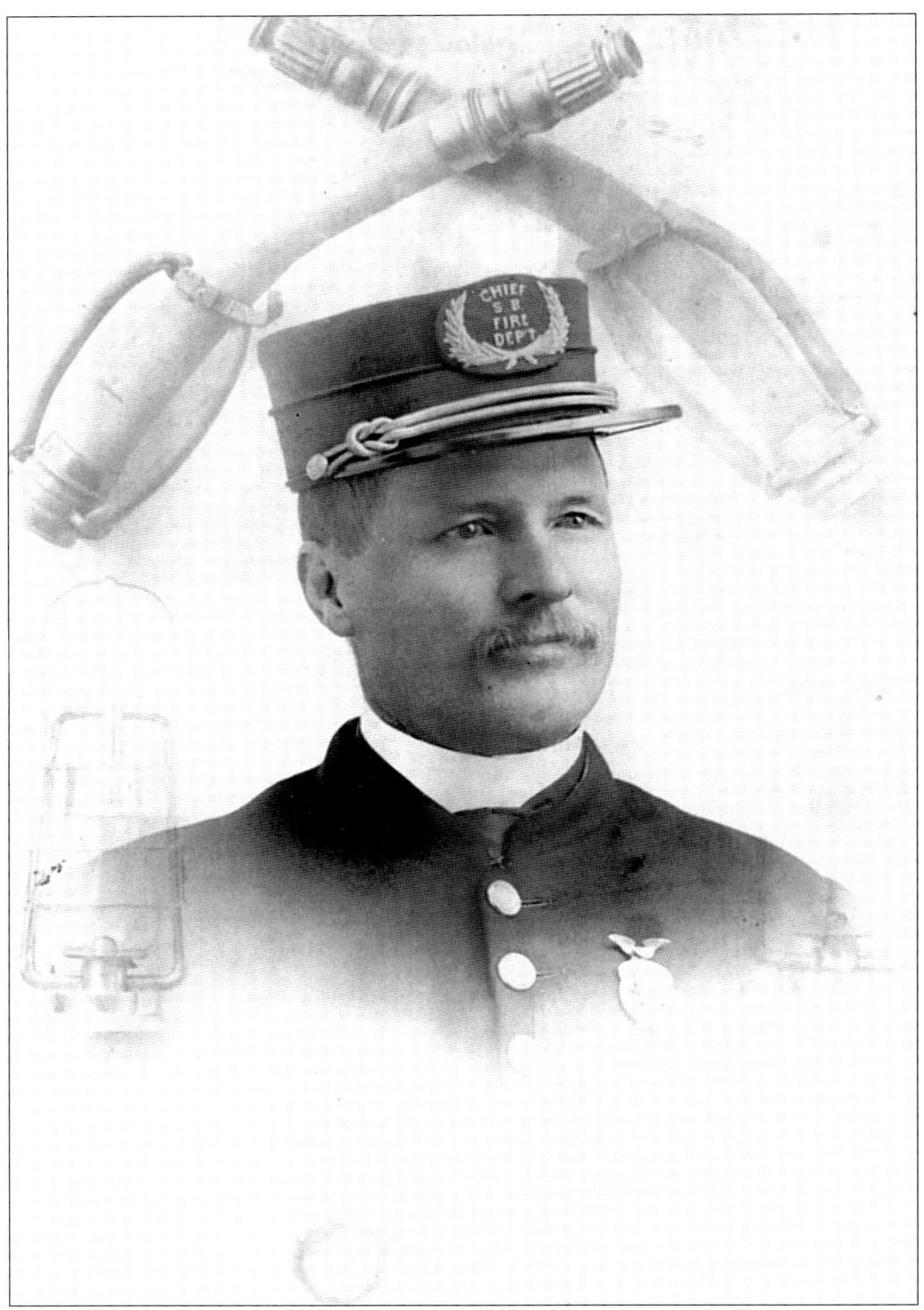

In December 1888, Dave Wixom became fire chief. He started the reorganization of the department, making it partly paid in 1889. Chief Wixom stayed active in the city's expansion after leaving the fire department by becoming a city trustee in 1894 and, later, mayor.

Two
Reorganization
1889–1909

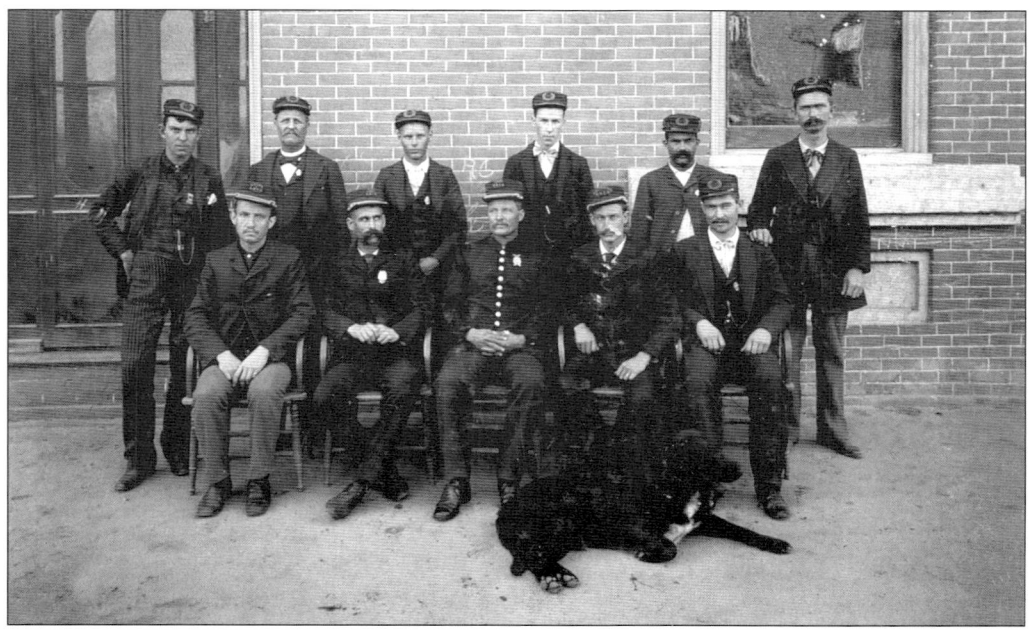

Fire Chief Dave Wixom is seated in the center with Assistant Chief J.H. "Hamp" Tittle and Driver Al Glatz to his right. The dog, named Chief, was popular throughout the city.

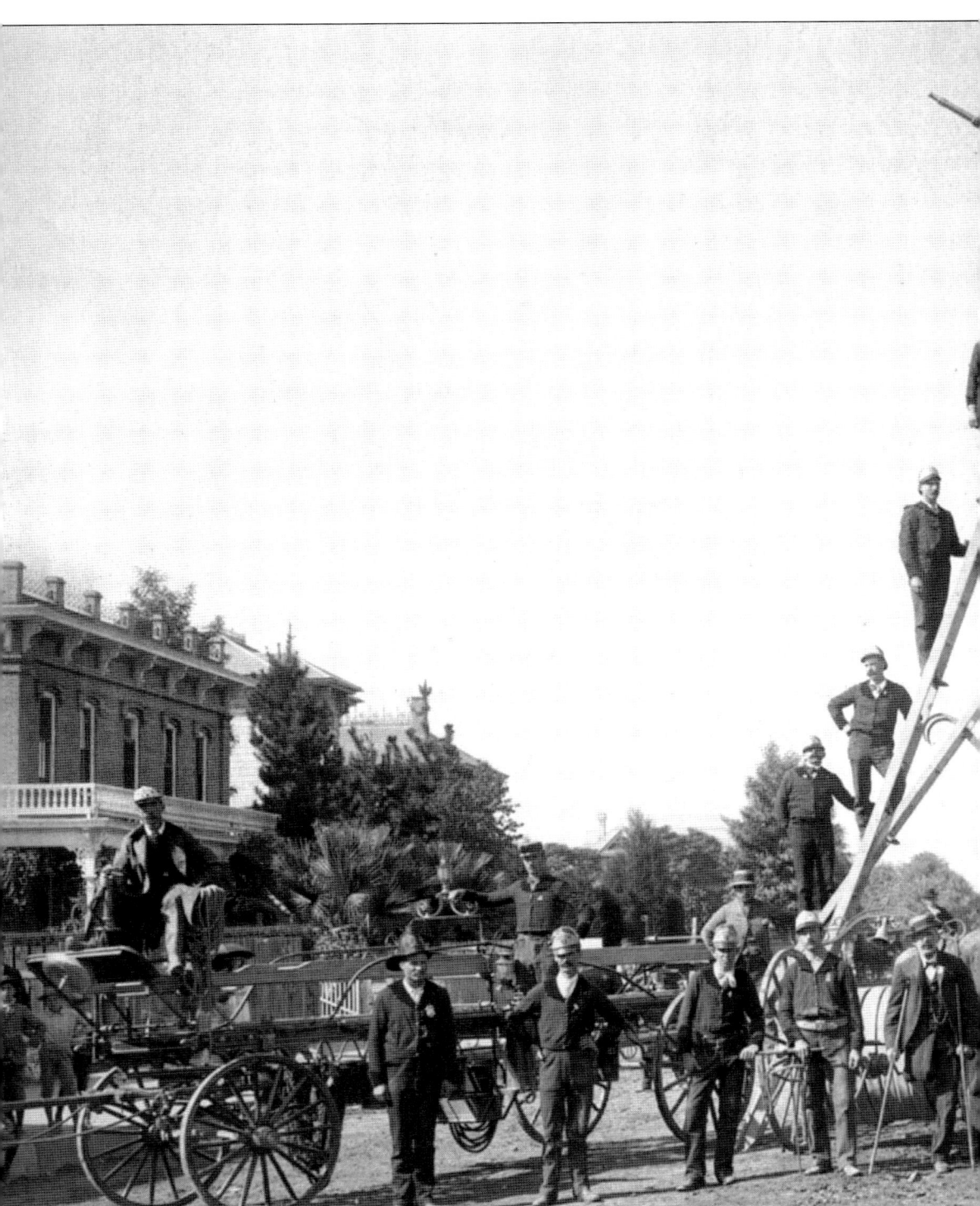

In February of 1889, the trustees of the city bought a span of horses. "Frank & Sam" worked in the streets by day and at night were harnessed to pull the steamer that was formerly pulled by hand. In September 1889, a horse-drawn hook and ladder was also purchased. This photograph

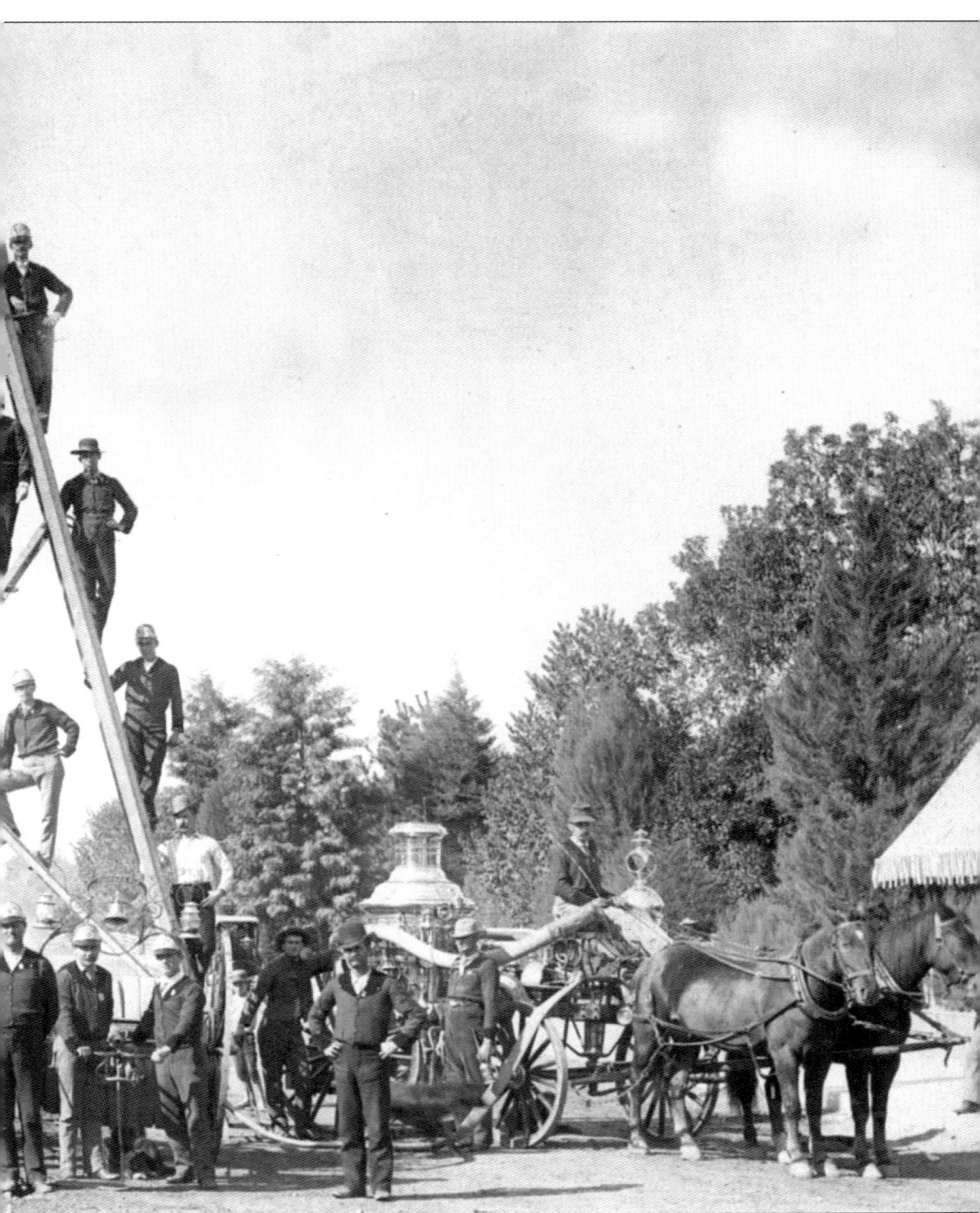
was taken at the corner of Third and D Streets in 1889. The ladders put together in an "A" frame was for this photo only. This would have no practical use at a fire.

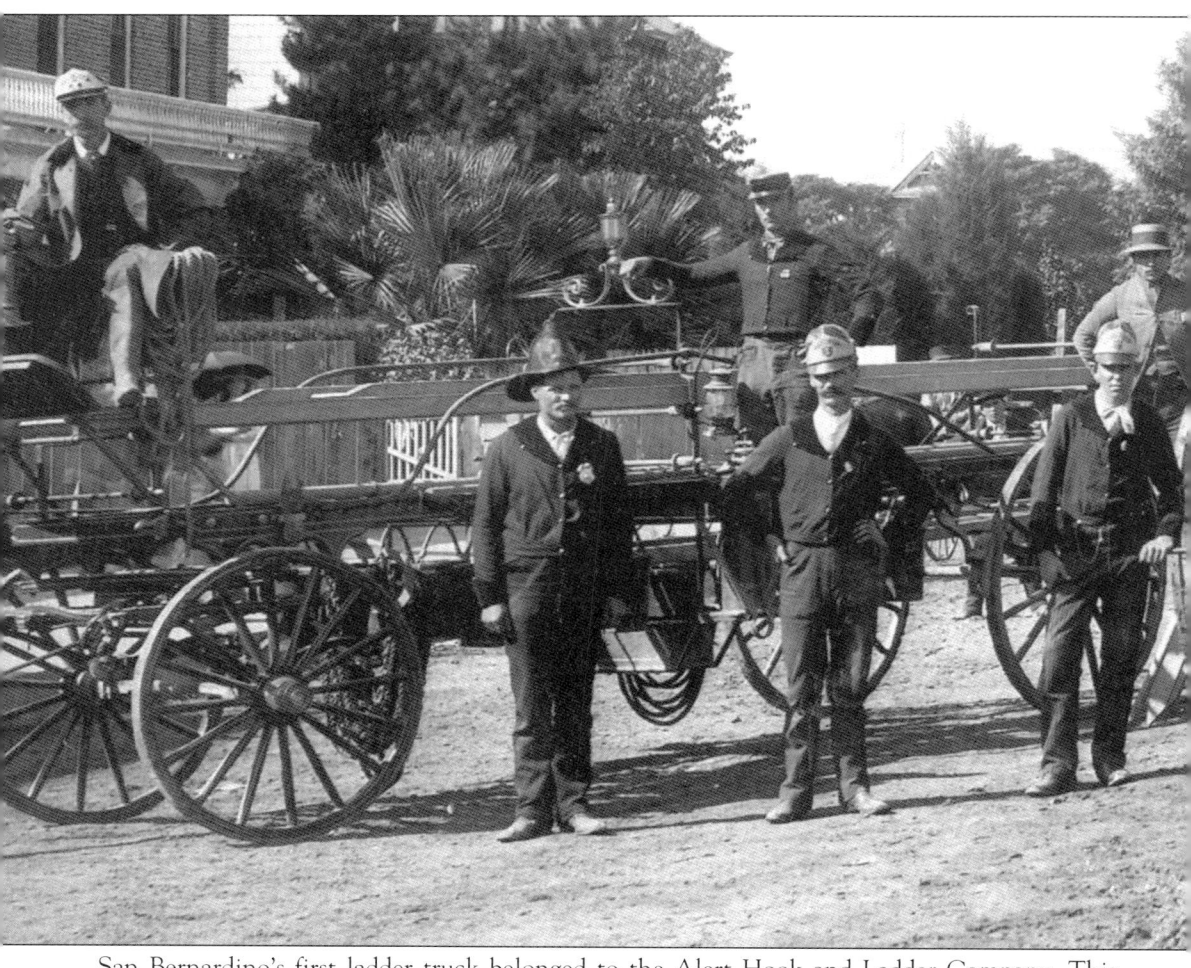

San Bernardino's first ladder truck belonged to the Alert Hook and Ladder Company. This horse-drawn truck carried a complement of ground ladders from 12 feet long up to 50 feet long as well as axes, hooks, and other necessary tools.

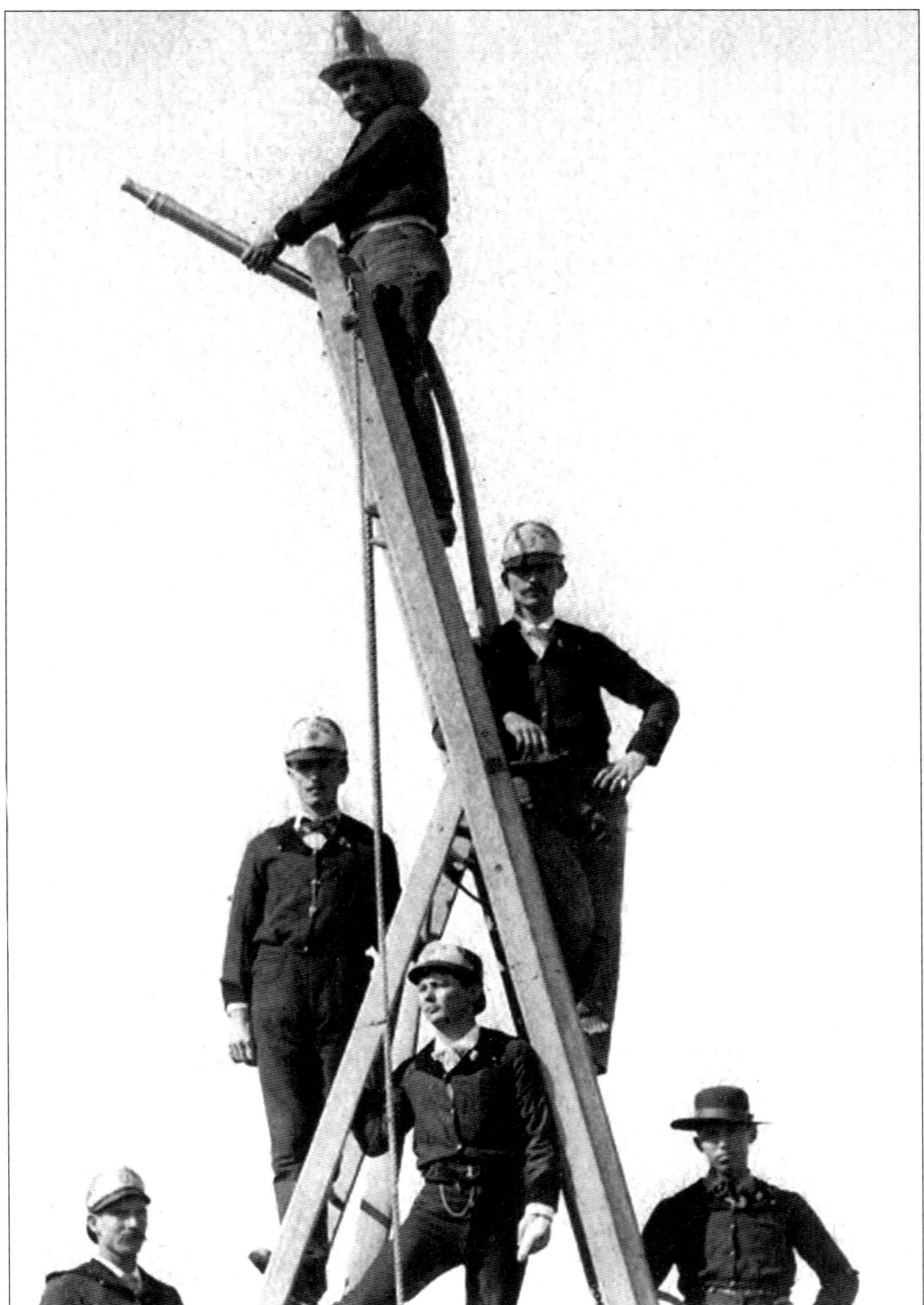
The brave men of the Alert Hook and Ladder Company pose for the camera. The fireman on the top wears a traditional leather helmet, while the other firemen boast the newer "jockey-style" helmet. These were also made of leather but were far less protective.

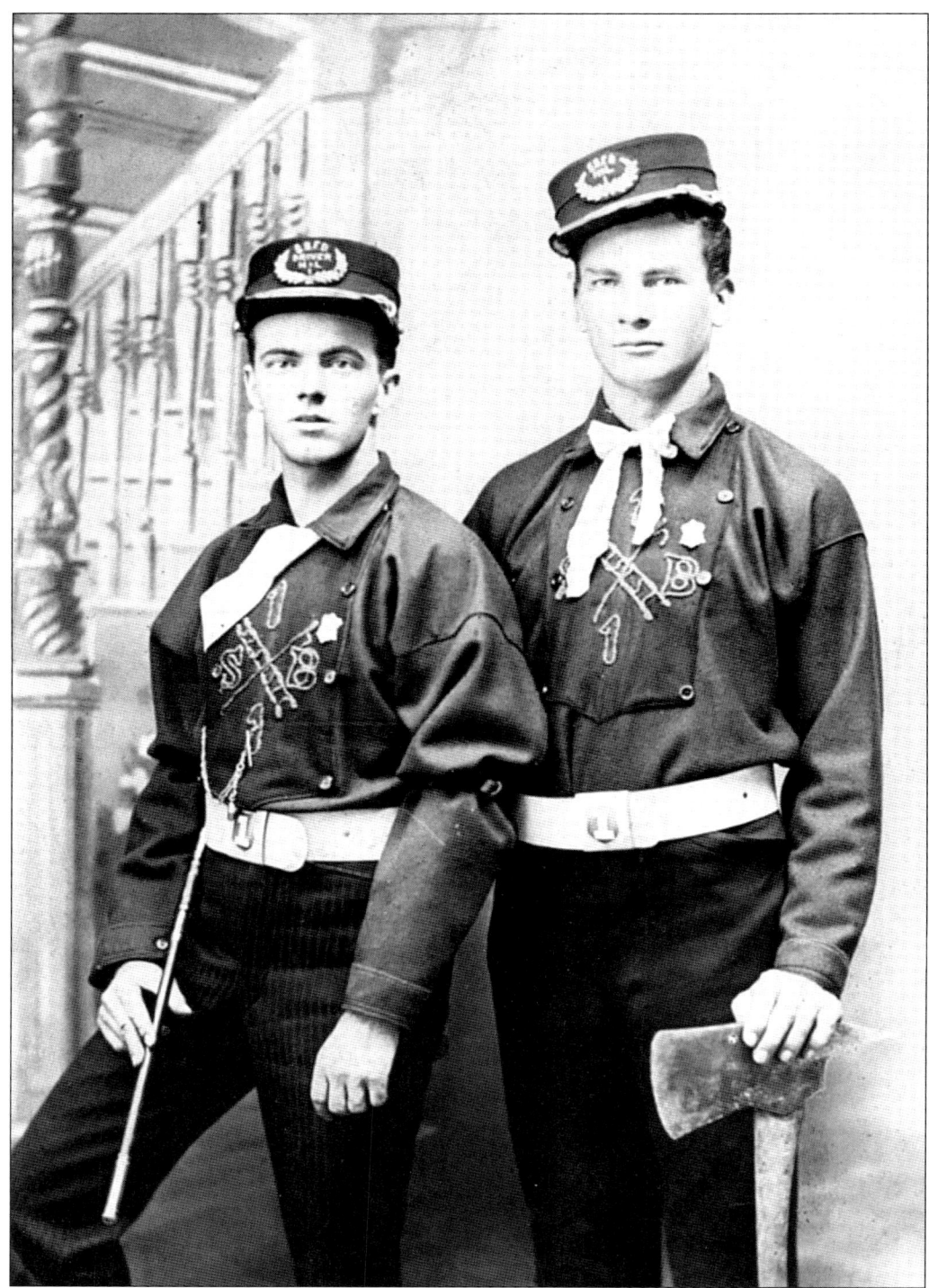

The young member of the Alert Hook and Ladder Company on the left and holding a whip is the driver, while the man with the axe is the fireman. Both are wearing the traditional bib front parade shirts and parade belts, which were for show only and were not worn at fires. Their badges are sterling silver and hand engraved.

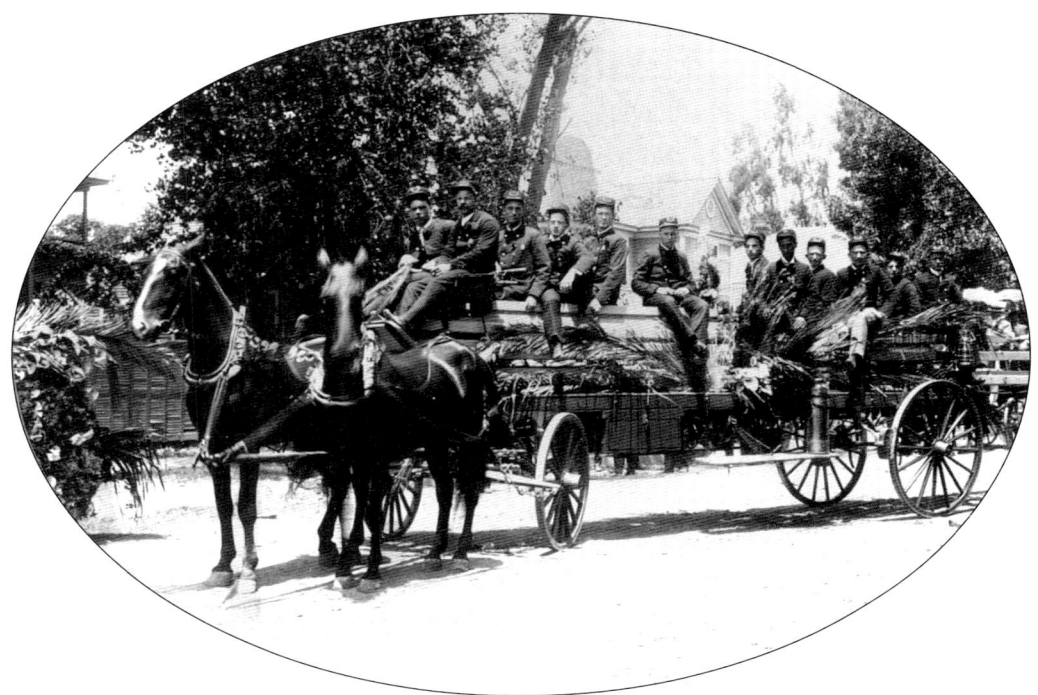

The Alert Hook and Ladder Company decorated their truck with palm fronds for this parade. The men are all wearing their dress uniforms.

The hook and ladder truck is probably out for the training of a new driver or a new horse. Two horses usually pulled this rig. As well as ladders, the truck carried buckets and soda-acid fire extinguishers for use on small fires.

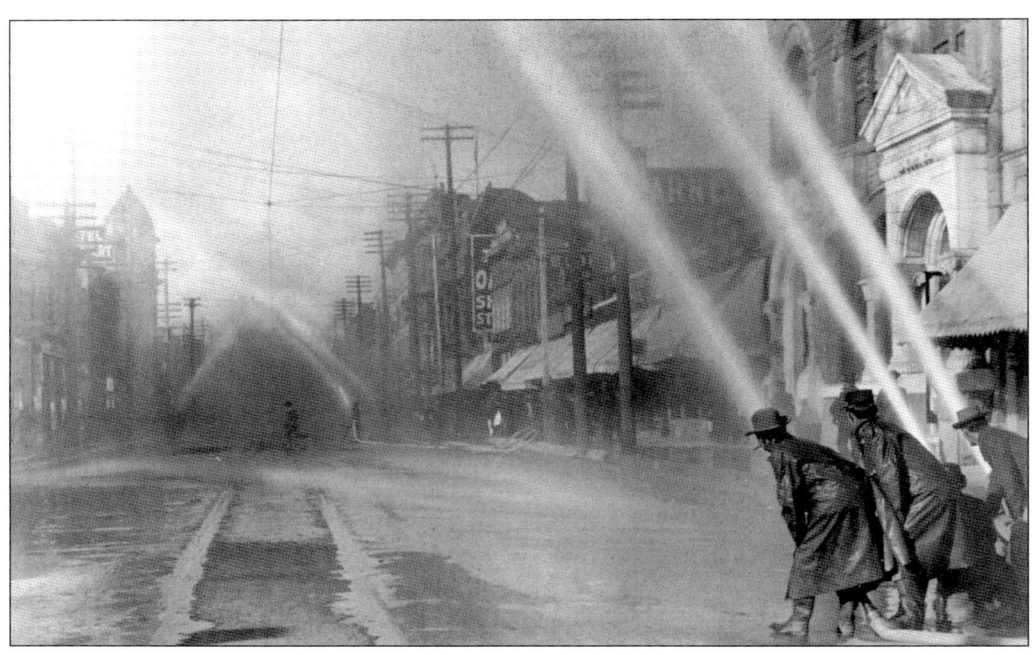

Prior to 1890, the city was supplied by a water system for firefighting purposes that depended mainly upon cisterns and an open flow of water. Pressure was obtained by the use of a hand-drawn steamer to pump water. In 1890, a closed water system with high-gravity pressure was installed and a horse-drawn hose wagon replaced the steamer. The water pressure was so good that the hoses could be connected directly to the hydrants. The cost of this in 1890 was an expensive $150,000. Today, San Bernardino has in excess of 4,000 fire hydrants.

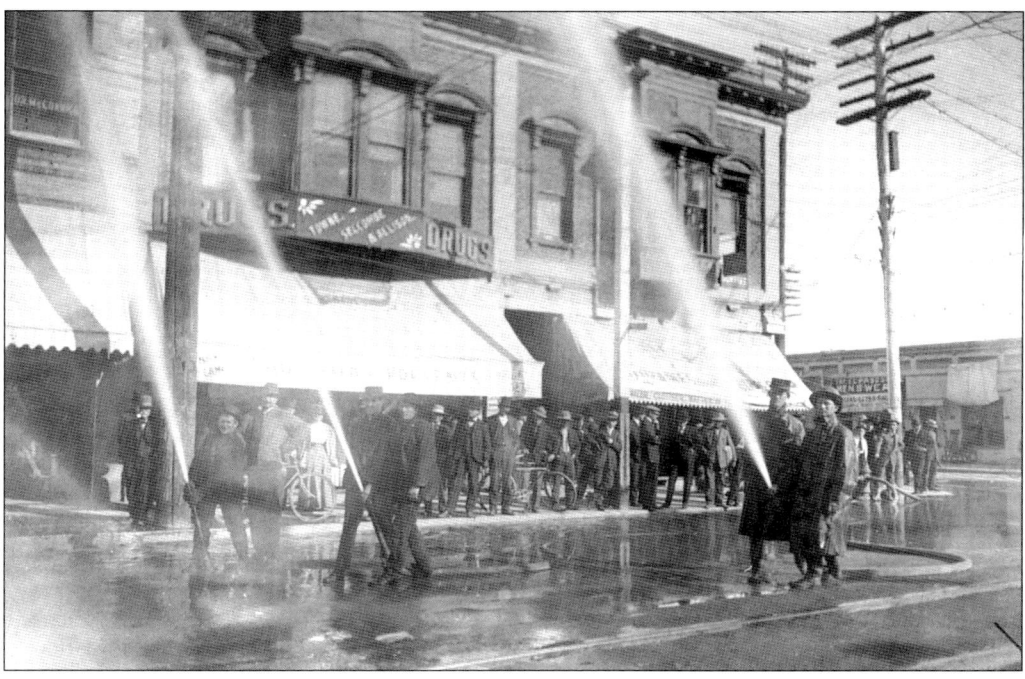

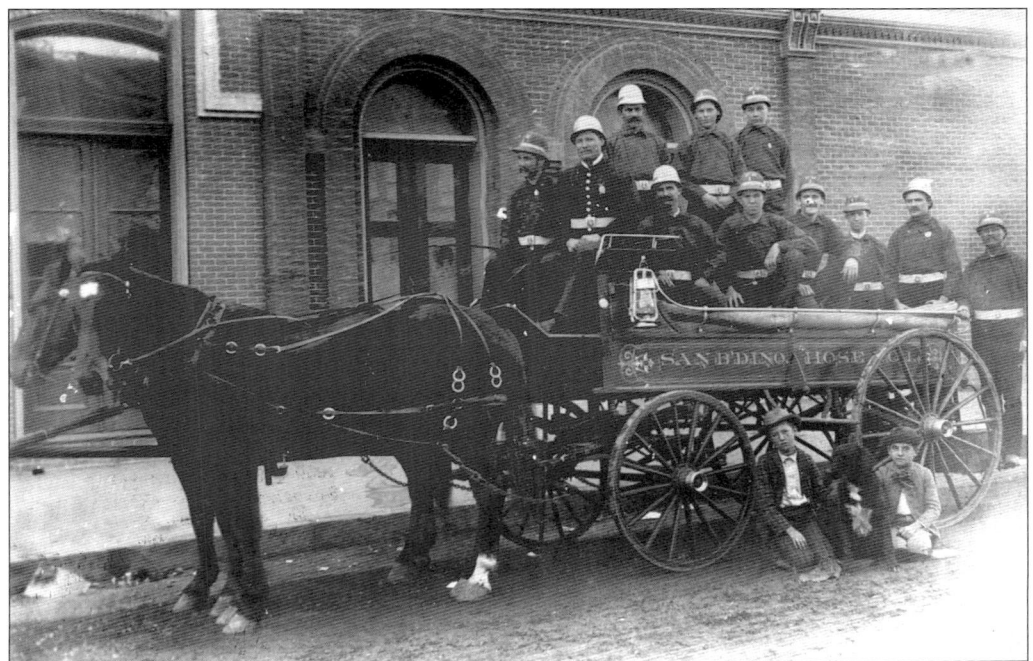

Because the hydrants themselves provided good water pressure, a more effective way to carry hose was needed. In 1890, Allen Iron Works built a horse-drawn hose wagon in San Bernardino. Chief Dave Wixom sits in the front seat and Chief, the dog, is below.

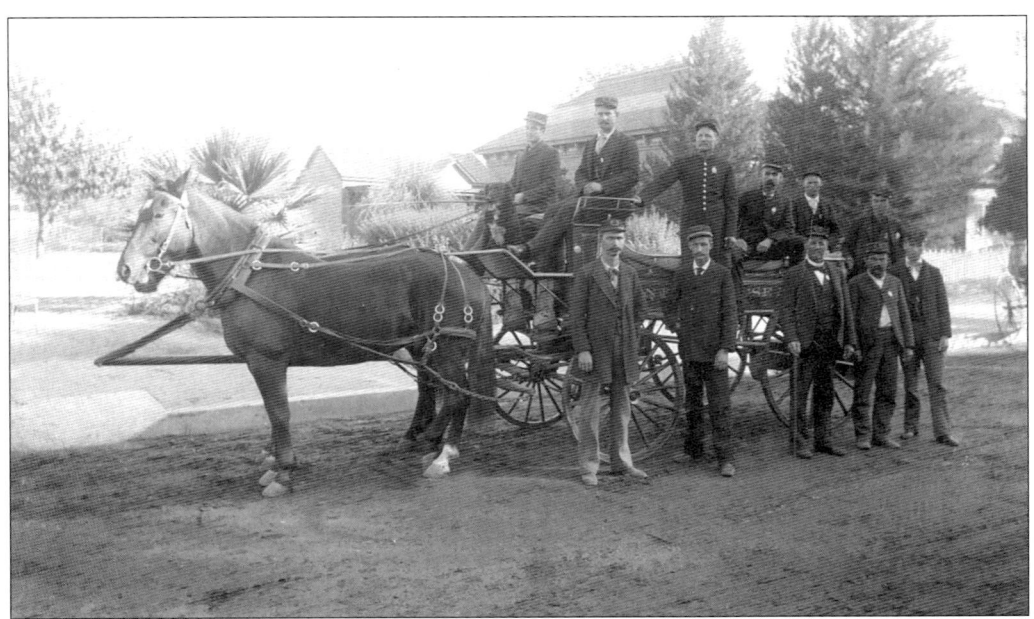

In this photograph, Chief Wixom poses on the side of the wagon and Chief is up on the footrest. The horses they used were thoroughbreds. The two teams primarily used were "Frank & Sam" and "Dick & Prince."

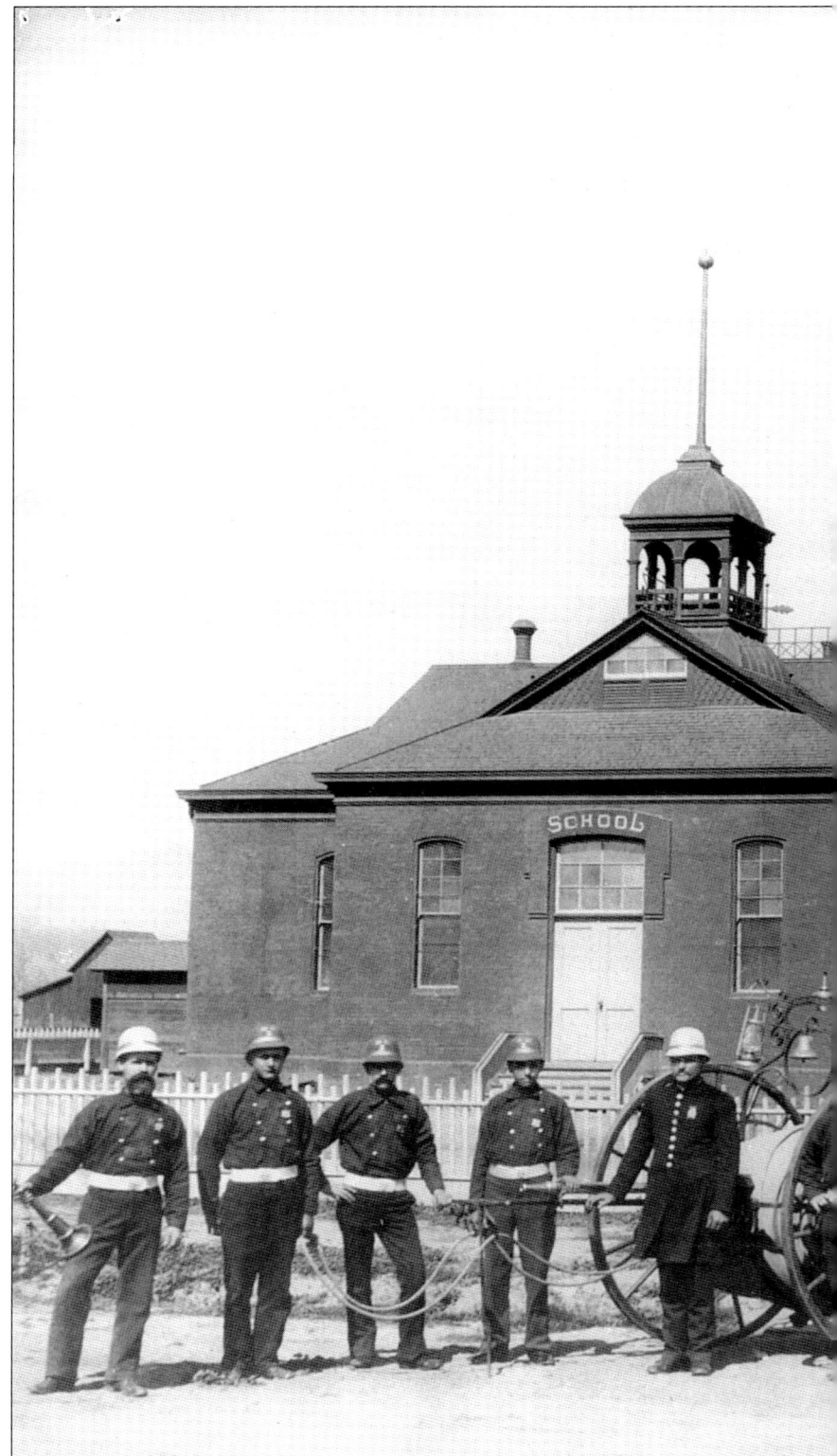

In December 1890, a second station was built in the north part of town at Ninth and F Streets. Instead of just being called Station 2, it was named the Deluge Hose Company, and it consisted of a single hand-drawn hose cart that was formerly "Pioneer #1." The schoolchildren next door were likely distracted quite a bit by their neighbors.

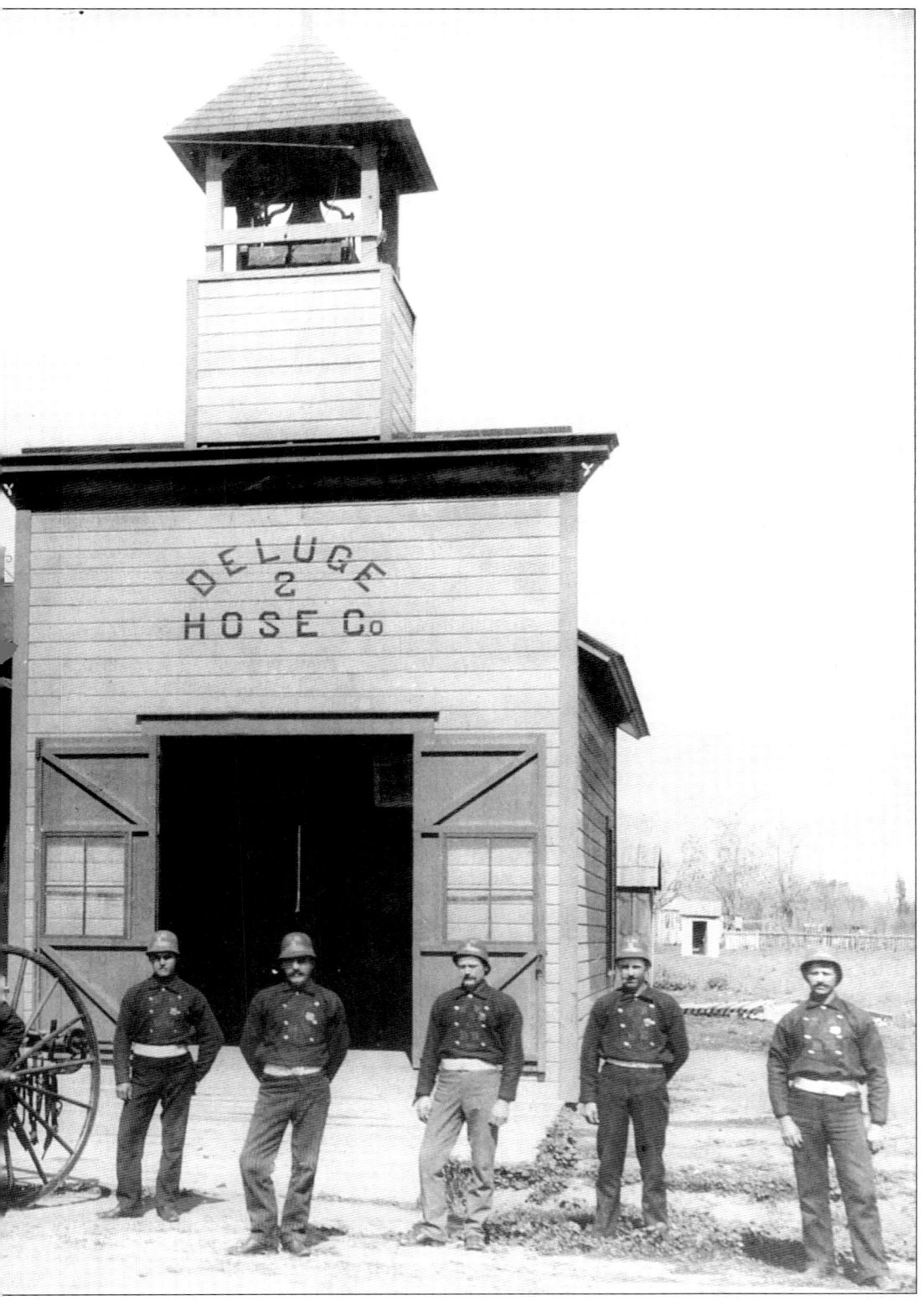

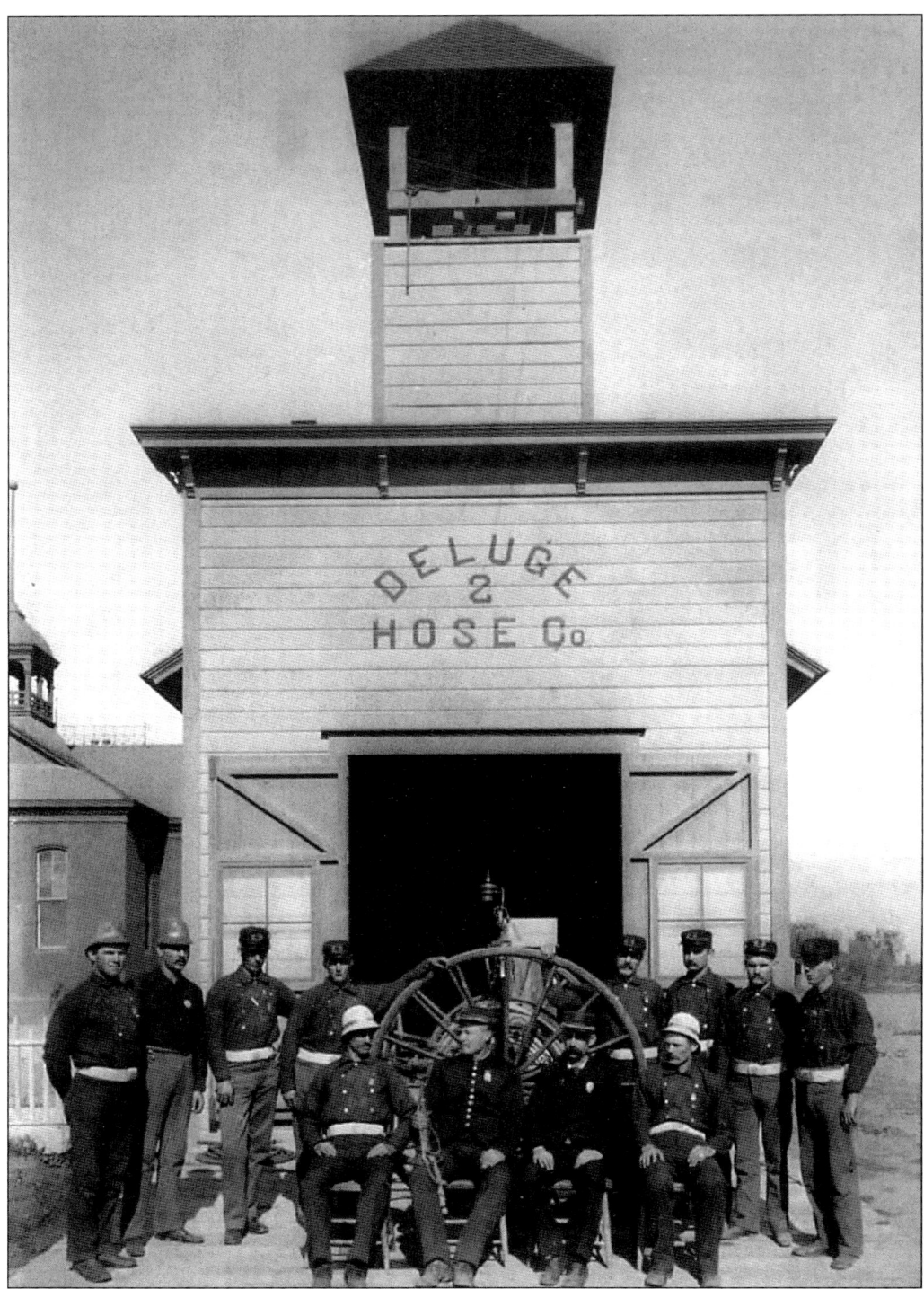
Chief Dave Wixom, seated second from left, and Assistant Chief J.H. "Hamp" Tittle, seated third from left, pose with the men of Deluge Hose Company #2. This company was in existence until May 1894. From the Deluge Hose Company #2 Logbook in 1892, an order had to be made that "Men shall not 'monkey with the bell' except for fires and membership meetings."

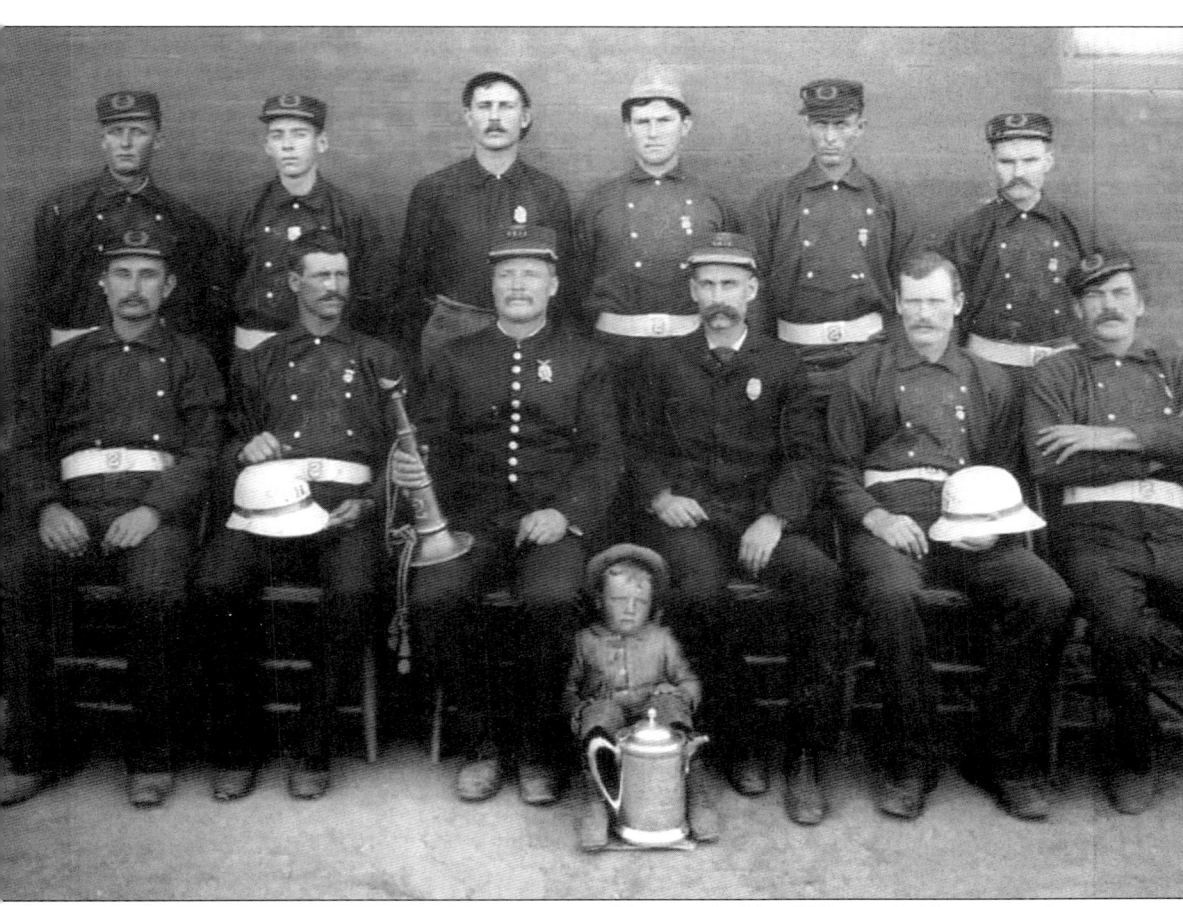

The men of Deluge Hose Company #2 are pictured here with Chief Wixom holding a speaking trumpet. These devices were used as megaphones at fires to amplify the chief's orders above the din. They were also a symbol of authority and are used today in the design of badges and collar brass. The water pitcher being held by a child in this image was probably a presentation item from the company to the chief or vice versa.

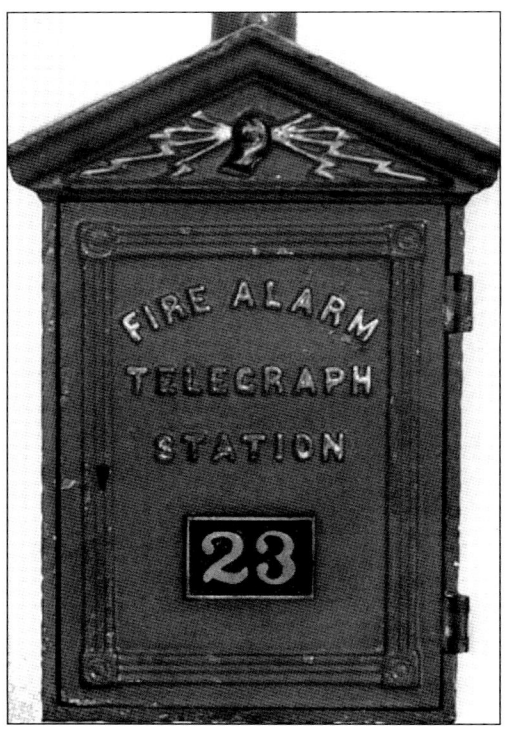

In April of 1891 an electric alarm system with six fire alarm boxes, a tower bell, and a house gong was installed in the city. See page 126 for an example of a house gong.

ire Alarm Boxes

Box No. 4—Corner E and Fifth streets.
Box No. 12—Third and E streets.
Box No. 13—Third and D streets.
Box No. 14—Third and C streets.
Box No. 15—First and E streets.
Box No. 23—Third and G streets.
Box No. 24—Fifth and G streets.
Box No. 25 - Santa Fe Depot, Third street.
Box No. 31—Seventh and C streets.
Box No. 32—B street, between Fourth and Fifth.
Box No. 34—Tenth and D streets.
Box No. 35—Sixth and D street.
Box No. 41—Ninth and F streets.
Box No. 42—Seventh and G streets.
Box No. 43—E and Seventh streets.

The keys are to be found at the residences nearest the boxes. After turning in an alarm remain at the box until the Department arrives.

Those with telephones will please ring up Central, locating the fire, and Central will notify the Department.

Each fire alarm box has a different number, and when activated, it transmits that number to a central station where that number can be located on a chart. The fire companies then respond to that location.

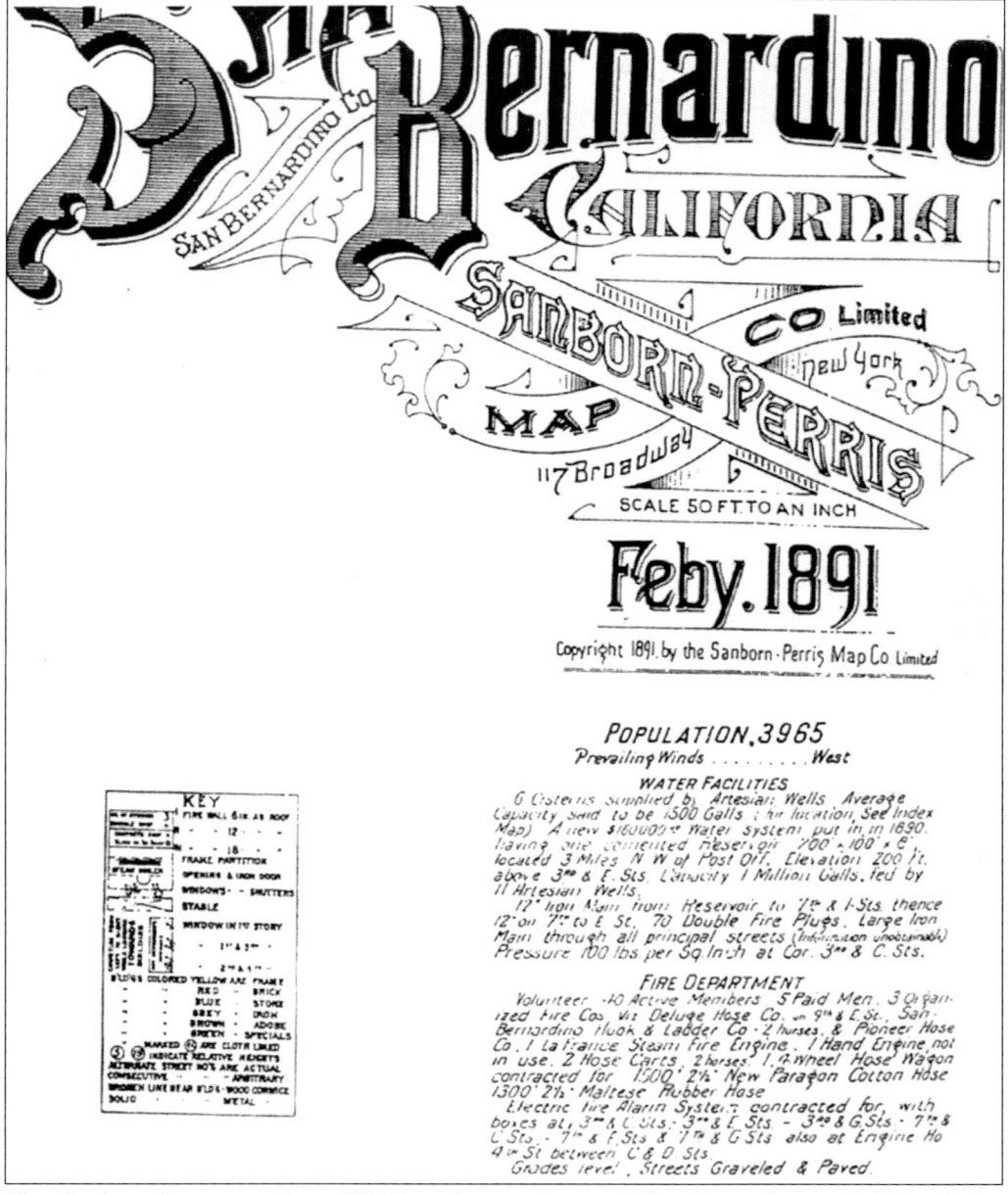

This Sanborn-Perris map from 1891 lists the population of San Bernardino at 3,695 with the fire department having 40 active members. That is a ratio of 1 fireman per 100 people. Today's ratio is approximately 1 firefighter per 1,340 people, which is accomplished by advances in technology, as well as fire prevention laws and building materials.

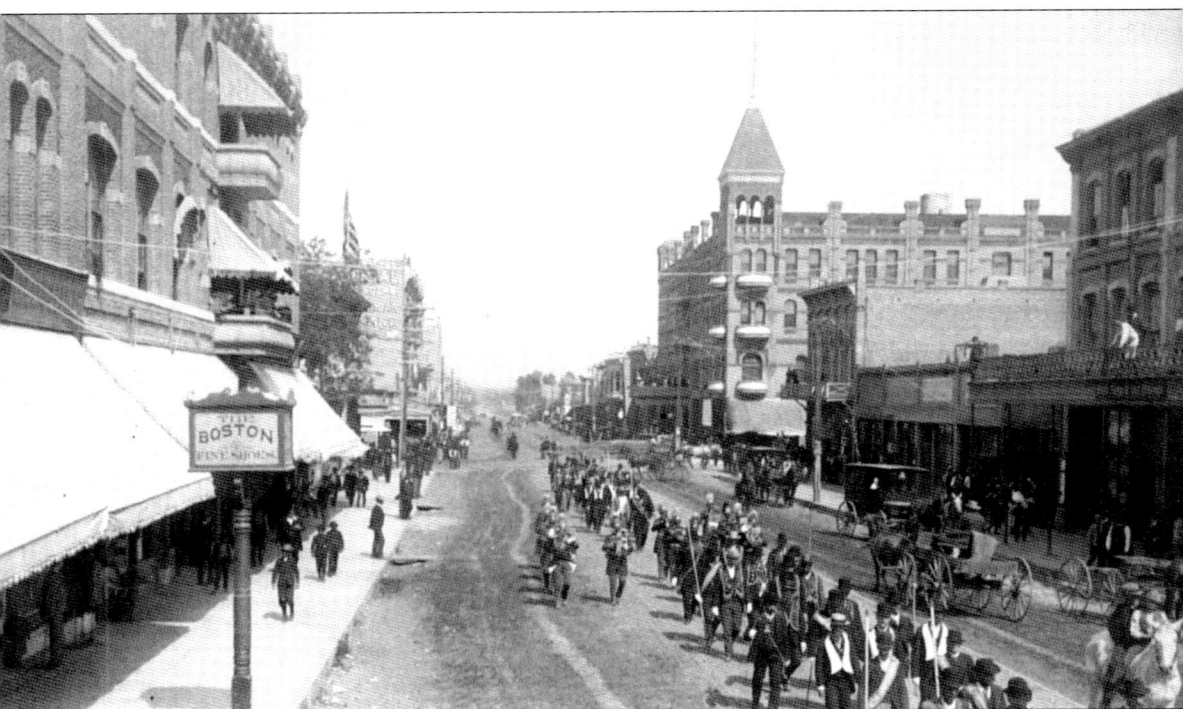

Located at Third and E Streets, the Stewart Hotel (center) was a magnificent four-story structure and the place to stay when visiting San Bernardino. The local newspaper even printed a column dedicated to who checked in and out of the Stewart Hotel. The structure was 150 feet square with a courtyard in the middle. Built at a cost of $150,000 it was said to have been the finest hotel structure south of San Francisco. The citizens of the town took great pride in this hotel with some 400 fully furnished rooms. On November 5, 1892, the building caught on fire.

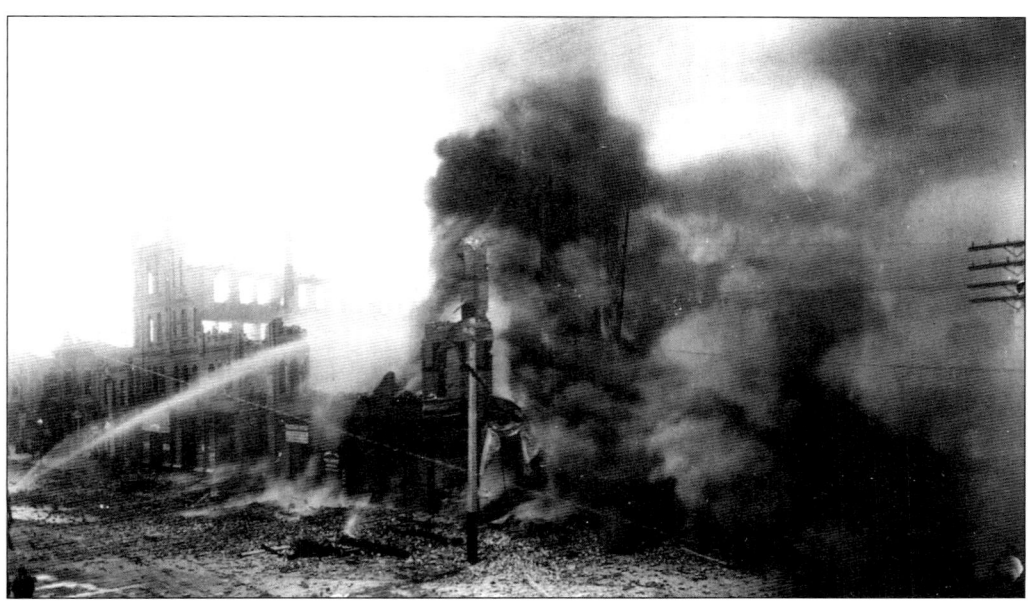

The *1901 Souvenir-San Bernardino Fire Department* book reported the following details from that 1892 conflagration: "On this eventful and well remembered occasion, every member of the fire department responded to the sound of the fire bell, as if by magic, and each one it seemed tried to outstrip the other in deeds of daring and heroism. The mighty odds were against them and in a few short hours the beautiful and majestic Hotel Stewart, with the majority of its rich and expensive contents, lay a mass of smoldering ruins. Weak, weary, maimed and heartbroken, the firemen withdrew from this pitiful scene. This had been their first and ever to be lamented defeat. Many were injured and one brave fellow was carried home with a broken leg, from which he has never fully recovered." The fire was a severe blow to the town as well as the stockholders.

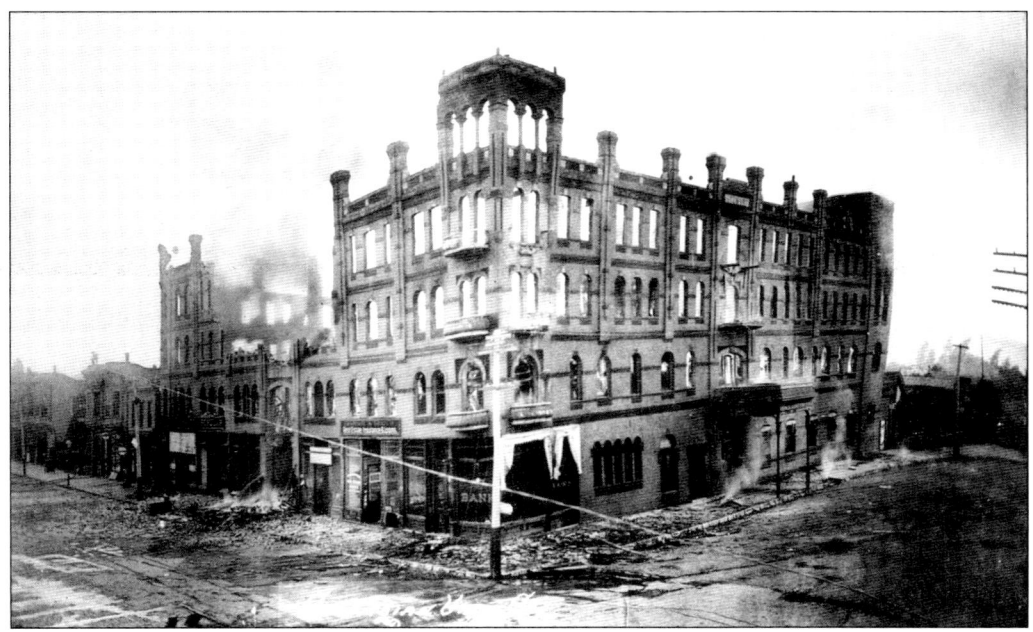

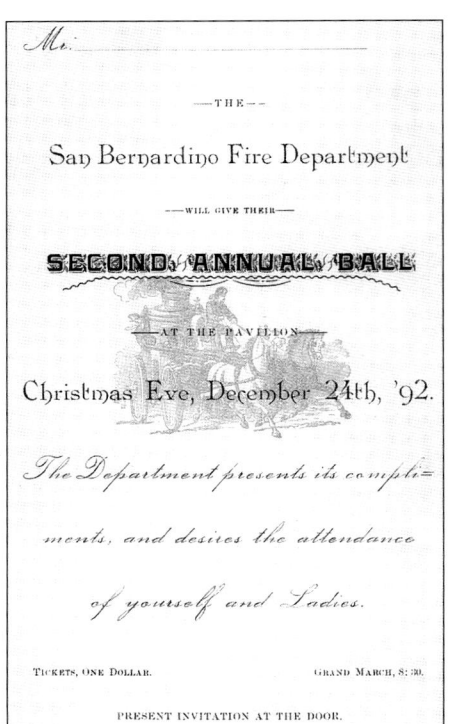

In the late 19th and early 20th centuries, a very important social event in many cities was the "Firemen's Ball." They were usually very extravagant affairs. Firemen wore their parade uniforms and ladies wore their best gowns. An orchestra provided the music and guests danced and sang. The songs and music were usually dedicated to the firemen. The event was organized by a firemen's committee and the funds from the ball usually went to a widows' and orphans' fund or a fund to buy more life-saving equipment.

The entire town knew Chief, the dog, and considered him a member of the fire department.

(San Bernardino Daily Courier, August 18, 1893.)

"CHIEF" DEAD

THE PET OF THE FIRE DEPARTMENT PASSES AWAY

Chief is Dead! Poor fellow, he fought hard against death, but the grim monster claimed him, and he now sleeps in his lonely grave, from which no canine returneth. No more will the deep tone of the fire bell wake him from his rest. He has answered his last call. The Chief was the Newfoundland dog that belonged to the fire department, and was raised by Driver Glatz. Chief was the favorite of all the boys, and he in return knew all of them. No matter where Chief was, when the bell rang he made his appearance in front of the hose house and kept up a howl until the horses lashed forth, then he led them. He went to every fire, and last Sunday when the alarm was turned in poor Chief could not respond; he was too near death. Yesterday he died and was buried, and now the boys wear a solemn look, as Chief is sadly missed by them all.

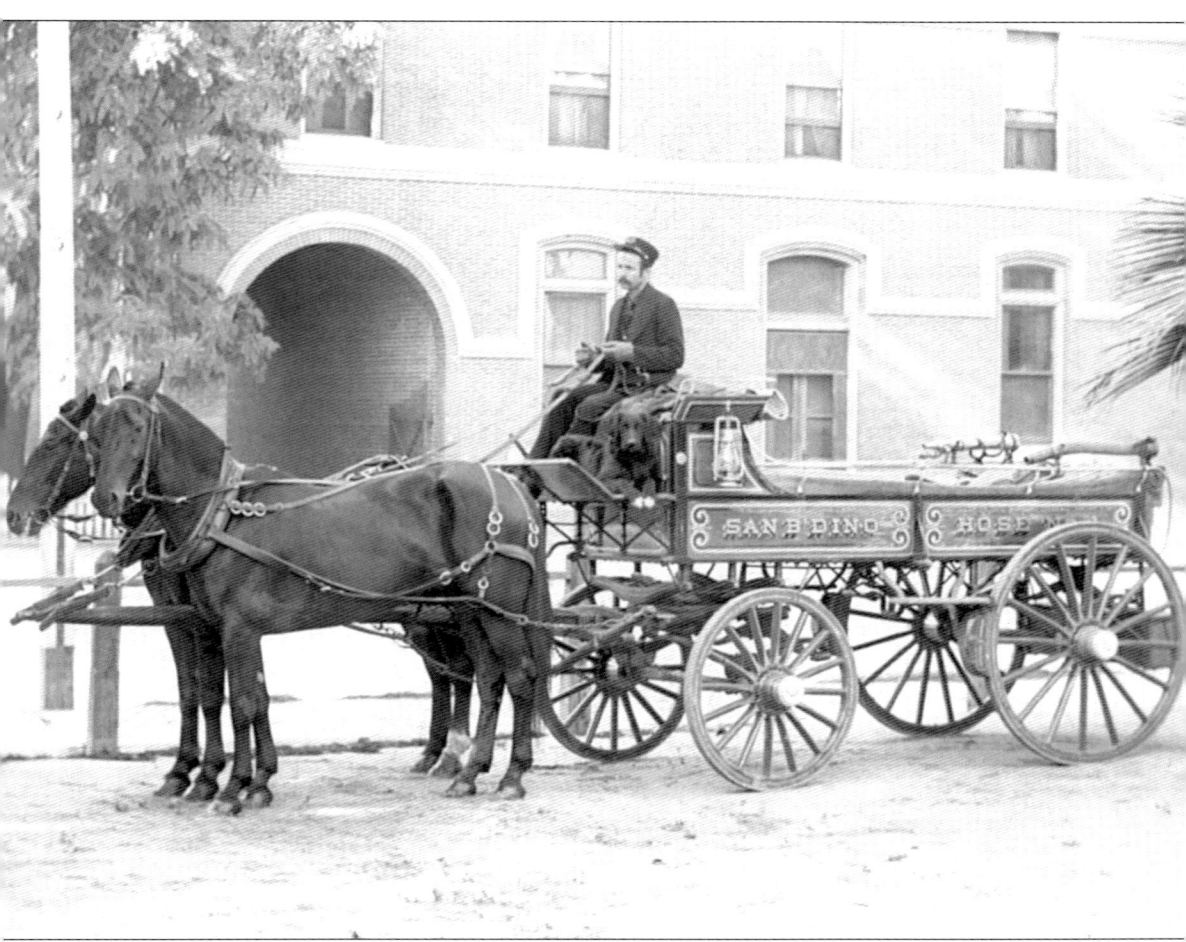

In August of 1894, Chief Dave Wixom resigned and his assistant, J. Hamp Tittle, was appointed chief. During the administration of Tittle, in April 1896, the hose wagon was made stronger and became the first ball-bearing fire apparatus on the West Coast. Al Glatz is the driver. The dog on the footrest appears to be a puppy and possibly an offspring of the well-loved Chief. This wagon was restored in 1997 and participates in many parades.

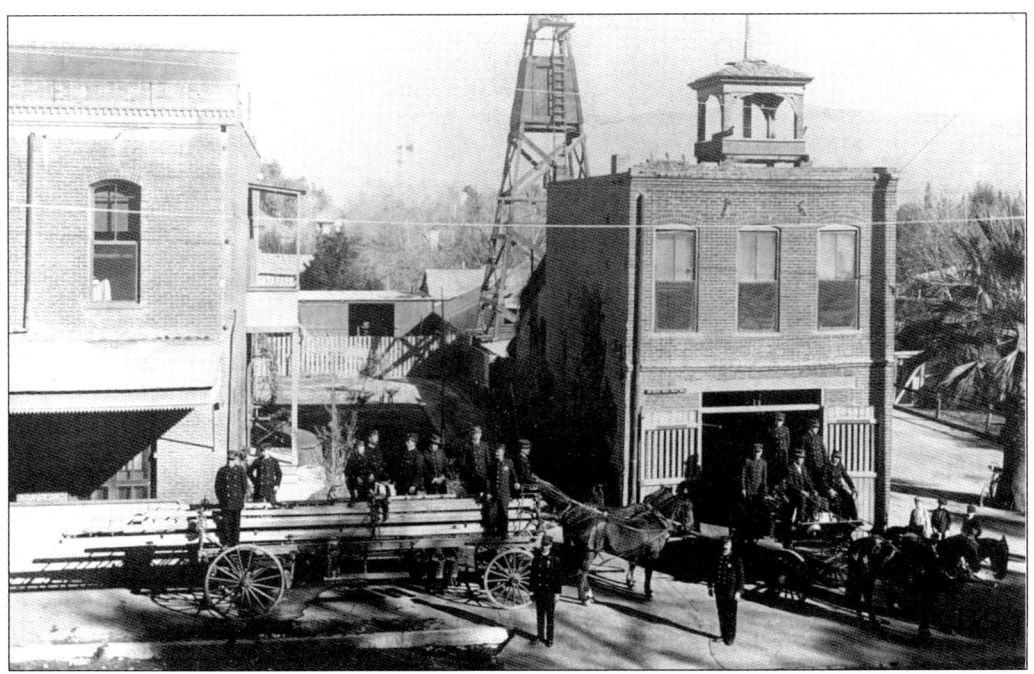

The hose wagon and ladder truck are pictured here in front of the first fire station at Third and C Streets (now Arrowhead Avenue).

This image shows a hose wagon and ladder truck in 1896. Soda-acid fire extinguishers were added to the hose wagon for use on small fires.

Note the small monkey in the bed of the hose wagon in front of the firehouse. It might have been another mascot of the fire department.

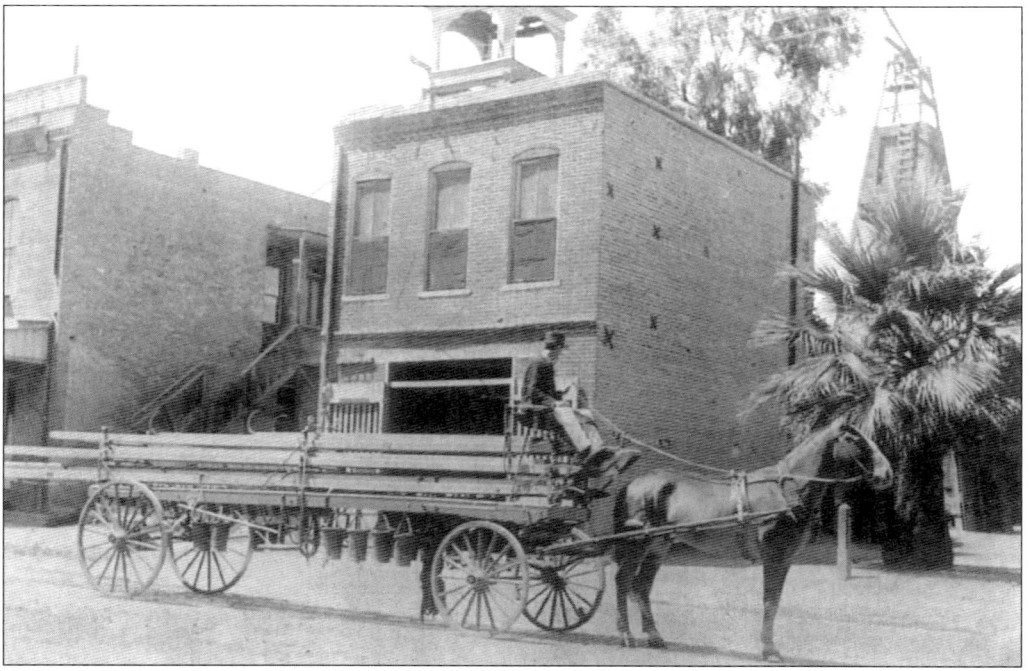

The whereabouts of this ladder truck, pictured in front of the firehouse, are unknown.

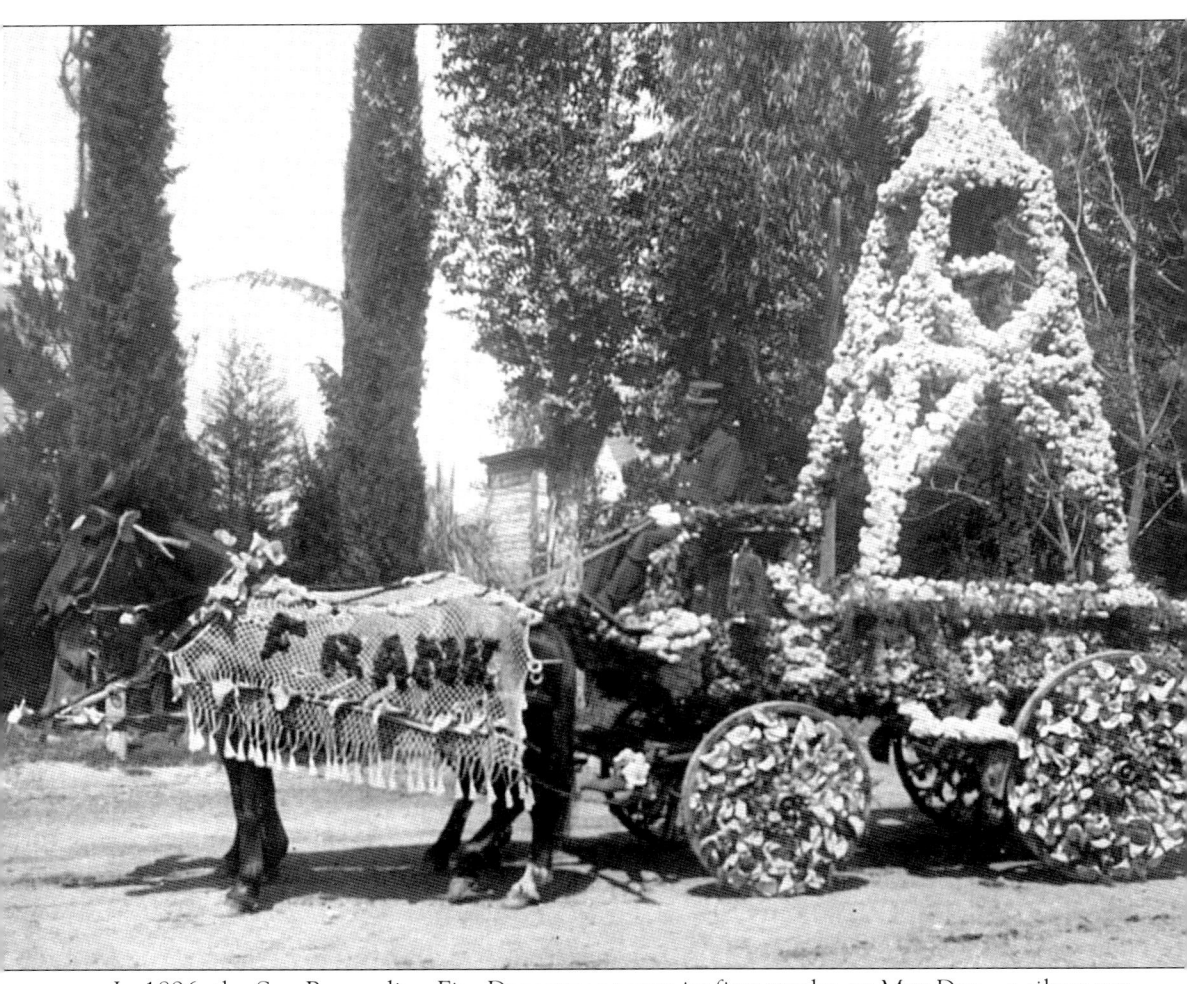

In 1896, the San Bernardino Fire Department won its first trophy on May Day—a silver cup for the best-decorated team. One of the original horses, Sam, died in that same month and the city purchased a new pair of thoroughbred roadsters, "Dick & Prince." The death of Sam grieved the entire community, and so, the city held a funeral for him, as he was a pioneer of the fire department.

The fire department was a big part of every celebration, like this one held on the Fourth of July. Chief Tittle resigned in August of 1897, and O.M. Stevenson was appointed as the new chief. The hose wagon and station were highly decorated. The hose wagon is hitched with four horses.

The hose wagon pictured here is decorated for an unknown celebration. Every square inch is covered in flowers. Even the name "Duke" is spelled out on the horse. They probably had their fingers crossed that there wasn't a fire.

37

In April of 1900, a street fair was held in Riverside with many fire departments represented. The San Bernardino Fire Department won first prize in the ladder contest, as well as second prize in the hose contest. The following year, at the San Bernardino Street Fair in May, the San Bernardino Fire Department again won first prize in the ladder contest. In the hose contest on July 4, 1901, in Santa Ana, the second prize was divided between the Santa Ana and San Bernardino Fire Departments.

In 1901, a souvenir book was published by "J.H. Tigner and Company, Los Angeles." It contained the history and up-to-date information about the San Bernardino Fire Department. It included this photo of trophies won by the San Bernardino Fire Department.

On March 25, 1907, Chief George Stephens, who served as chief from 1897 to 1908, laid the cornerstone for the new fire station on Fourth Street, near D Street. The total cost for construction was $13,385.

Firemen pose proudly in their dress uniforms in front of the new firehouse in 1907. Fire Chief George Stephens is standing in the center in front of the pole. Future Chief Frank Starke is to his right.

The hose wagon and ladder truck were also photographed in front of new firehouse in 1907. The horses would only be at this station for five years.

Three
Dawn of the Motorized Age
1910–1930

In this 1910 parade, firemen pull a hose cart down the street, and soon, parades such as this one will be the only place that such hand-drawn and horse-drawn vehicles will be put to use. The motorized era has arrived.

In 1910, the first piece of motorized fire equipment—in the form of a Pope-Hartford hose wagon—was added to the department. Later, the hook and ladder truck was modernized by the addition of a 1912 Pope-Hartford tractor.

Fire Chief George Stephens sits in the passenger seat of the Pope-Hartford hose wagon in 1910. This wagon carried 1,000 feet of hose, 30 feet of ladders, had two 30-gallon chemical tanks with 200 feet of chemical hose, and cost $5,600.

In this opposite view of the Pope-Hartford the people pictured are unidentified. This engine is now in a private collection near San Diego, California.

The first full-paid chief on the department was Frank G. Starke, who was appointed in 1911 by Mayor Dave Wixom. He is the tall man in the center.

Chief Frank Starke stands with his hand on the Pope-Hartford, while the others in the photograph are unidentified. Note the horseshoe hanging on the lamp on the front of the station—a reminder that the horse-drawn era is nearing an end!

The first "National Orange Show" parade in 1911 included San Bernardino's first motorized engine. The "National Orange Show" is still an annual event in the city of San Bernardino.

This 1907 interior view of the station shows Al Glatz sitting in the driver's seat. He was an original fireman in 1878 and later became the driver of the hose wagon.

In the early days, the fire chief had to provide his own transportation, and Chief Frank Starke chose a Thor IV motorcycle. The gas tank reads "Chief S.B.F.D."

A new Station #2, located at Seventh and L Streets on the west side of the city, opened its doors in 1911. Chief Frank Starke retired in 1917 and died a short time later.

Succeeding Starke as fire chief was L.M. Field, who was appointed in June 1917 by Mayor Joseph Catick. Pictured here is Station #2. The Pope-Hartford engine appears to have chains on its tires to help it maneuver the muddy streets, while a poster advertising the National Orange Show hangs on the lower door to the station.

This is the last known photograph of the hose wagon while it belonged to the fire department in 1919. Al Glatz, who was appointed chief in that year, drives the wagon one more time. He died less than a year later. (See page 10 for a photograph of Glatz in 1878, and page 33 of Glatz in 1896)

In 1921, Chief O.W. Newcombe was appointed the new fire chief by Mayor Samuel McNabb. At this time, the San Bernardino Fire Department employed ten full-paid firemen and had no more volunteers. The Pope-Hartford engine is on the left and the Pope-Hartford tractor and ladder truck is on the right.

In 1923, the first of many pieces of Seagrave fire apparatus was purchased. The 1923 Seagrave engine is on the left and the 1926 Seagrave 75-foot aerial ladder truck is on the right in this posed picture.

In 1925, a hose wagon with a Moreland chassis was received. This unit only carried hose. It did not have a water tank or a water pump.

Ernie Leffen was appointed fire chief in 1925. His first term lasted until 1927, and he served two more terms after that. In February 1926, this new Seagrave 75-foot aerial ladder truck was delivered.

Also in 1926, a new Seagrave 750-gallons-per-minute pumper and two new 400-gallon-per-minute pumpers were added to the department's equipment.

52

All of the fire department's equipment is shown here. In front is the original horse-drawn ladder truck with the motorized Pope-Hartford front end. The 1926 aerial ladder is pictured next to it.

Pictured here is the crew at the central station on Fourth Street. Up until the 1950s, the fire chiefs had to provide their own vehicles.

53

In 1926, the fire department made many changes, including the addition of three new stations. Station #2 was at Tenth Street and Mt. Vernon Avenue on the west side of the city.

The new Station #2 replaced the old Station #2 at Seventh and L Streets. Shown here are Capt. Edwin Timaeus, Engineer Alfred Leffen, and Fireman Roy Glover.

All of the new stations were identical. Pictured here is Station #4, which was located at 2641 North E Street on the north end of the city. The current Station #4 is in a newer building on the same site.

Engine 4 was the smaller Seagrave "Suburbanite," capable of pumping 400 gallons per minute.

Here, Engine 2 is probably going to participate in a parade. The three young firemen are wearing helmets with high fronts, numbered 1, 2, and 3. These were made for this special occasion.

This is another view of Station #2 with its regular crew.

As mentioned earlier, Chief Ernie E. Leffen served three terms starting with one in 1925–1927. Frank D. Scovel was then appointed chief for the 1927–1929 term, and from 1929 to 1933 E.E. Leffen served another term. He was followed from 1933 to 1935 by L.O. Newcombe, then for six months in 1935 by H.A. Purden Sr. From 1935 to 1939, E.E. Leffen served his final appointment as chief. He is pictured here with his personal vehicle equipped with a red light and siren.

Another of Chief Leffen's personal vehicles is pictured here; it is also well equipped with hose and two backpack water pumps for fighting small fires.

This Seagrave Suburbanite was used as "Squad 1" in the mid-1930s. It could pump 500 gallons per minute. This is a Seagrave "Factory Photo" done before delivery of the new engine.

Kids and adults alike couldn't help but join in and pose for this photograph of every piece of equipment belonging to the San Bernardino Fire Department.

On Thanksgiving Day in 1935 at 7 a.m., the Stewart Hotel caught on fire again.

The fire started in a ventilator shaft and quickly spread to the top floor of the structure.

All available fire apparatus was used to fight the blaze, including pumpers from the neighboring cities of Colton and Redlands.

Luckily, no one was severely injured in the fire, but many of the more than 100 residents of the hotel had to be rescued by firemen, including a fox terrier that was carried down a ladder.

C.N. Niday was appointed fire chief in 1939, and he served in that capacity until 1948. Niday is shown here posing on Engine 3.

Engine 3 was a Seagrave 1,000-gallons-per-minute pumper. It is shown here on Route 66 near the western city limits.

National Fire Prevention Week started in America on October 9, 1911 on the 40th anniversary of the Great Chicago Fire—a disaster that killed 250 people and destroyed 17,430 buildings at a cost of $168 million. Fire Prevention Week is still celebrated today as it was in this photo of an engine with a banner proclaiming "Clean Up Before You Burn Up."

In the mid 1900s, firemen worked more shifts and longer hours than they do today. They trained a lot but had significantly fewer calls—more than 35 times less in 1928 compared to 2002. The early firemen had more spare time, and the equipment was kept polished and spotless, but you can only train and clean so much. This is where "Firemen just sit around and play checkers" comes from. The miniature fire equipment shown on this page were made by Capt. C.R. Gaddie and Fireman Paul Webb. They were made from the wooden boxes Velveeta Cheese came in.

Four
MODERIZATION
1940–2003

Chief C.N. Niday is seen here training his men on a "ChemOx," which allowed the firefighters to enter into smoky buildings.

Chief Niday (with the cigar) observes the testing of a "Deluge Gun" on the old Moreland motorized hose cart.

During World War II, the fire department formed an auxiliary unit to help fight larger fires and be involved in Civil Defense work. The members of the auxiliary unit were given the same training as regular firemen. They were also trained to work at Air Raid Shelters, give First Aid, and know how to survive and treat victims of chemical warfare.

In years 1946 and 1947, four Seagrave 750-gallons-per-minute pumpers were bought for the department.

In 1946, Station #5 at Eleventh and E Streets was manned.

Station #5 was originally built in 1941 and was used by the water department. The building had adobe walls.

In 1947, Station #6 was built on the corner of Gilbert Street and Waterman Avenue. This building later became a flower shop after Station #6 was relocated in 1970s.

In this picture, Chief C.N. Niday appears on the left, while fire prevention chief "Pop" Purden is next to him.

Chief Niday is pictured with the mayor, James Cunningham Sr., and members of the city council at the opening of Station #6.

In 1948, D.E. Littleton became fire chief, a position he held until 1970.

Chief D.E. Littleton (standing) celebrates his birthday at the Central Station. An avid collector of fire-related items, he and Assistant Chief Sieger Pruiksma were responsible for the preservation of the early history of San Bernardino's fire department.

The National Orange Show had a huge, ornate building that measured 100 feet wide and 750 feet long and had a wood frame.

In July 1949, the building of the National Orange Show caught fire and burned to the ground in what was reported to have been the most spectacular fire in the city's history. A comparable Orange Show building was never constructed.

In 1952, the Fourth Street station was showing its age. More modern fire equipment was outgrowing the door openings that had been built for horse-drawn equipment. This is an artist's plan for a new station.

The new Central Fire Station was built in 1952 at 452 Mt. View Avenue. The living quarters were upstairs, and four fire poles made getting downstairs quick and easy.

Fire Station #7 at Fortieth Street and Electric Avenue was manned in 1953. It was also designated to house the north end's battalion chief. The station was built to provide fire protection in the rapidly growing "North End" of the city.

The fire engine at Station #7 was made by Kenworth. It was said that in order to stay in his seat, the driver had to have his seat belt on while pushing in the clutch.

Between 1953 and 1956, two Seagrave 1,000-gallons-per-minute pumpers were added to the fire department's equipment.

One of the new engines is seen here at the "Drill Tower" supplying four hose streams. The drill tower, built by firemen was torn down in the 1990 when it outgrew the training needs for the multi-story building.

These men test a new engine by "drafting" water from a pit that was supplied by a water main.

"Drafting" is the process of drawing water from a stationary water source like a like, pool, or reservoir. This new engine is supplying two 2 1/2-inch handlines from draft.

73

The fire department operated with two platoons, so that when one was on duty the other one was off. This photograph depicts one of the platoons in 1957.

In many fire departments, it is tradition that a round of ice cream is bought by individuals who make small mistakes, get their photographs or names in the newspaper, or do something for the first time. That's why rookies buy the most ice cream! From left to right these firemen are the future chief Ray Shaw, future battalion chief George Sheppard, and future battalion chief Lyman Marshall.

On the side of the new Central Station, these firemen decided to pose for the camera while checking out their equipment. The men on the ladder are "locked in" with their left leg through the rungs and their insteps pressed against the lower rung. While the ladder truck was motorized, the aerial ladder was still made of wood.

The author (standing, fifth from the right) and the rest of his kindergarten class visit the fire station in 1958.

Fire Station #8 was manned in 1958 in the 3800 block of Harrison Street. Its engine was a 1926 Seagrave, and most of the drivers were younger than the equipment.

Fire Station #9 was opened in 1960 in the 200 block of Meridian Avenue on the western boundary of the city.

The training tower, or "Drill Tower," stood behind Station #4. It was a four-story wooden structure and was built by firemen.

These firemen are doing training on the workings of a fire alarm box. There were over 225 boxes in the city at the time in the '50s and '60s. In the mid-1970s, the boxes were removed to the high number of false alarms, and the wide-spread use of the telephone.

Firemen practice the "auditorium raise." This balancing act was seldom used in actual emergencies but the maneuver was also used to boost confidence.

Firemen had to take turns being the victim when training with the life net. Life nets were removed from trucks in the late 1970s because they were deemed dangerous for firemen and largely ineffective in assisting victims. Large airbags are now used for someone needing to jump. Airbags were originally designed for stunt men.

Firemen trained on the use of a "water pipe" operation. This provided an elevated platform by using an aerial ladder from which to apply water to a fire.

These firemen train with the self-contained breathing apparatus. This was a relatively new invention in the 1950s and was superior to the previous ChemOx-type of breathing apparatus.

The fire department created the positions of "drill master" and "assistant drill master" who were responsible for training firefighters. Under their direction, the drill tower was in use almost every day.

It takes six men to raise a 50-foot ground ladder, which can reach the fourth floor of a building.

The San Bernardino Fire Department got into the business of providing medical aid in the early 1950s. In 1959, this unit responded to 102 "resuscitator" calls. In 2002, the fire department responded to 21,663 requests for medical aids, quite a dramatic increase.

It was a rare sight to see three firemen on a tailboard, except at the Central Station.

Firemen try to get support for a bond issue in 1962 to buy new equipment and replace #2 and #4 and to build two new ones.

The bond issue passed and the department bought three Seagrave 1,500-gallons-per-minute engines, matching the one bought in 1961, as well as a new Seagrave 100-foot aerial ladder truck.

The new Seagrave 100-foot aerial ladder truck is pictured here in front of the Central Fire Station at 456 Mt. View Avenue.

The old ladder truck and the new ladder truck appear in this picture over one of the new engines.

83

Stations #2 and #4 were identical in appearance and were both replaced following the approval of the bond issue. The bonds also paid for Stations #5 and #10.

Station #4 was the only new station to be built on the site of the old one.

84

In 1963, the Westervelt Furniture store caught on fire. It is interesting to note that even with the thick black smoke, only one fireman appears to be wearing a breathing apparatus.

This fire attracted a number of onlookers.

The building was in the heart of the downtown area, and the San Bernardino County Courthouse is visible in the background.

The building was so large that the fire had to be fought on two perpendicular streets. The two ladder trucks are located one street south of the furniture store.

Here, water is being lobbed on the fire from a side street. The building in the background is the Fox Theater.

The fire was a complete loss but fortunately did not spread to the surrounding buildings.

87

In 1964, a new station was built at Baseline Avenue and H Street to replace Station #5. Chief Dwight Littleton, the mayor, Donald Mauldin, and an unknown councilman are pictured here at the ribbon-cutting ceremony for the new Station #5.

The new station was large enough to house an engine, a ladder truck, and that battalion chief's car or a brush tanker. Each station had a fire alarm box in front of it in case someone came to the station to report a fire and the crew was out.

A separate building behind Station #5 housed the automotive shop for fire department vehicle service and repair. The repair shop is still in the same location.

This is an unknown artist's rendering of Station #10, which was to be built on National Orange Show property and leased to the city. The station has a round shape to resemble an orange, and there is even a stem on top, which serves no purpose except decorative.

Station #10 was built at the corner of Mill Street and Arrowhead Avenue in 1964. It still has the "stem" on top.

Also in 1964, this Seagrave "Eagle" with a three-section articulating boom was put in service at Station #10.

The Eagle was very different to operate than the ladder trucks, and the Seagrave Company only made a few of these vehicles.

The fireman behind the Eagle brings a water supply line in. The Eagle was pre-plumbed with a pipe from the back of the truck to the basket, making a quick attack with an elevated stream possible.

The Eagle prepares to make an elevated stream operation at Crocker Bank.

A battalion chief directs an elevated stream from a ladder truck, while the Eagle directs its own stream and supplies another hose line from the elevated position.

A ladder truck makes a cliff rescue of an amateur climber on the side of Little Mountain in the 1960s.

Colton fire chief Ed Temby established the "Bombero Program" (*bombero* is Spanish for fireman) in the early 1960s, and the program lasted into the mid-1970s. The men posing with Chief Littleton in this photograph traveled from all parts of Mexico to Southern California to learn American techniques of fire fighting. They were housed, fed, and trained by most of the surrounding fire departments.

Norton Air Force Base in San Bernardino had its own fire department, and at times, the two departments would work together. Chief Littleton is shown here with Norton's chief.

Santa Fe Railroad in San Bernardino had its own fire department as well. They also had a good working relationship with the city fire department.

In 1963, the fire department got its first helicopter when the California Office of Emergency Services loaned it to the department. The helicopter program ended in 1967.

The fire department's pilot was Capt. Don Hardenberg, and he flew helicopters for the U.S. Forest Service on a contract basis on his days off. He was killed in August 1968 when his helicopter crashed while fighting a fire in San Gabriel Canyon, north of Azusa, California. Hardenberg was a 26-year veteran of the San Bernardino Fire Department.

In 1970, the department purchased its first American La France (left) vehicle. In that same year, Harry Wainwright was appointed chief, a position he held until 1971.

In 1975, during the tenure of Raymond W. Shaw as chief (1971–1980), a station relocation program was completed, with Stations #3, #5, and #6 moving to new quarters and Station #8 relocating to the existing station adjacent to Patton Hospital.

Pictured here is the open house and dedication of the new Station #3 at Twenty-first Street and Medical Center Drive on the northwest side of the city.

Fire Chief Ray Shaw poses with Mayor W.R. "Bob" Holcomb and the city council at the dedication of Station #3 in October 1975.

Fire Station #5 is located at the extreme north end of the city, on Kendall Drive close to California State University at San Bernardino. The station housed a Seagrave 1,500-gallons-per-minute engine and a water tender, which is a military all-wheel-drive vehicle converted to fight grass fires.

Fire Station #6, situated on Del Rosa Drive next to Perris Hill, housed a Seagrave 1,500-gallons-per-minute engine, a Seagrave 85-foot aerial ladder truck, and a water tender.

Fire Station #8 is on the east end of the city at Highland and Orange Streets, next to Patton State Hospital. Visible in this photograph are a water tender and an engine that the fire department mans for the California Office of Emergency Services.

In 1975 two light helicopters were placed in service and housed at Station #10, located at Mill and Arrowhead Streets. These helicopters were military surplus and cost the fire department very little. This second helicopter program lasted into the early 1980s, when service and liability costs forced its stoppage.

Chief Ray Shaw started paramedic service in 1976 with just one unit, but the program grew to include 3 units and 23 certified paramedics only a year later. The small "Resuscitator" unit was put out of service. The "Resuscitator" was a two-man unit that did First Aid an "Artificial Respiration" before CPR.

The department also hired a registered nurse in 1976 who specialized in emergency training. Soon, all personnel were trained as emergency medical technicians.

Paramedics posing for this picture in the newspaper are, from left to right, Luis Cerda, Rick Winn, and Gary Zikratch. Dawn Curtis, the fire department's nurse, is the patient.

Firefighter-paramedics treat a victim of a traffic collision.

101

October 1978 marked the San Bernardino Fire Department's 100th anniversary, and the celebration included a parade through downtown San Bernardino. Many neighboring cities also participated in the event.

A banquet was also held as part of the anniversary festivities. This photograph shows City Councilman Jack Strickler presenting a plaque to Fire Chief Ray Shaw. The flag in the background was made especially for the centennial celebration.

Suppression and shop personnel combined their efforts to design and construct various pieces of equipment. This is one of nine brush tankers that were originally military support vehicles.

The hilly terrain in and around the city of San Bernardino is covered with vegetation, and summers brought many wildfires. The brush tankers, as they were called, had all-wheel drive and could maneuver on the steep mountain roads.

In some cases, fire is used to fight fire. The fireman in this photograph has a road flare in his hand to start a "backfire," but the timing and wind direction had to be just right. The practice of being comfortable in a seemingly harmless situation has long since passed. Today this fireman would be breaking safety regulations by not wearing full protective gear.

The engineer at the back of the rig controls the water supply and pressure in the hoses. This fire is in the "mop up" stage to make sure the fire does not rekindle.

Mayor W.R. "Bob" Holcomb (center) accepts the keys for a new engine belonging to the Office of Emergency Services. In the agreement, the engine could be used by the San Bernardino Fire Department as a reserve but had to be able to respond fully manned to any large emergency in the state at anytime.

This vehicle fire was started as a result of a traffic collision. In reality, vehicles seldom explode in just 30 seconds after a crash like they often do on television.

105

In February 1980, Gerald Newcombe was appointed fire chief.

On the morning of November 24, 1980, the annual autumn winds—the Santa Ana winds—were howling at 90 miles per hour when a fire started above the city in Waterman Canyon in the San Bernardino National Forest. This was the beginning of the worst fire in San Bernardino's history.

The San Bernardino National Forest comprises the entire northern boundary of the city and homes are built within the interface. Within hours, the fire had reached the city limits.

A firestorm often creates its own wind, and the mini-tornado of fire seen here is fairly common.

Winds reaching 90 miles per hour drove flames as high as 200 feet. Experts said the fire could not have been stopped at this point even with an infinite number of resources. (Courtesy of the *San Bernardino Sun*.)

A firefighter wets down a rock roof while a house with a shake-shingle roof burns behind him. During the height of the firestorm, it was next to impossible to extinguish a structure fire once it had started. The fire had a large impact on laws regarding shake-shingle roofs in wildland interface areas. (Courtesy of the *San Bernardino Sun*.)

Most of the 286 homes that were destroyed, burned within an hour after the fire reached the bottom of the foothills. For many homeowners, there was not enough time to pack belongings and evacuate. These people did manage to get a few things packed. (Courtesy of the *San Bernardino Sun*.)

Homeowners searched through the rubble, but the fire had been so hot that even metal had melted. Close to two dozen city firefighters and police officers were among those who lost their homes in the blaze. (Courtesy of the *San Bernardino Sun*.)

Some homeowners tried using humor as a way to deal with their loss. (Courtesy of the *San Bernardino Sun*.)

By Thanksgiving Day, the fire was mostly contained, and a traditional holiday meal was served in the fire camps. Many homeowners had to spend the holiday at an evacuation center or at the homes of other family members. (Courtesy of the *San Bernardino Sun*.)

A firefighter "mops ups" hot spots above the smoldering valley on Thanksgiving Day. The "Panorama Fire," as it was known, burned 23,800 acres, leaving 4 dead and 286 homes destroyed. Another 49 homes were damaged and another 64 structures were destroyed in the five days before the fire was contained. (Courtesy of the *San Bernardino Sun*.)

In 1982, the Central Fire Station was relocated from 456 Mt. View to 200 East Third Street.

The station housed an engine, a ladder truck, a brush tanker, a rescue vehicle, a battalion chief vehicle, and a breathing air re-supply vehicle, as well as the administration and fire prevention offices.

In 1982, before the old Fire Station #1 was torn down, an event was held there in which kids and many adults had the opportunity to eat firehouse chili, ride on an old fire engine, and slide down a fire pole (with the help of a safety rope).

In 1988, Station #11 was erected at 450 Vanderbilt Way, and the crew assigned to it took over hazardous materials response within the city.

From 1988 to 1989, Richard Moon served as San Bernardino's fire chief. On May 12, 1989, a runaway Southern Pacific freight train with 69 hopper cars carrying a product called "Trona" derailed in the Muscoy area. Seven homes were destroyed and four others extensively damaged. Of the five crewmembers aboard the train, two were killed and the other three injured. Two residents were killed and one was seriously injured.

On May 25, 1989, a Cal/Nev gasoline pipeline that was located directly beneath the point of impact of the previously derailed train exploded with a fire column spurting over 1,000 feet in the air. In the tragedy, 2 residents were killed, 3 received serious injuries, and 16 received minor injuries; 11 homes were destroyed and 6 suffered moderate fire and smoke damage.

From 1990 to 1997, William Wright served as fire chief, and he was the first to have been enlisted from outside the community. Chief Wright came from the Orange County Fire Authority where he had served as the fire marshal. In 1994 the fire department bought two new Seagrave engines and a 100-foot aerial ladder. Chief Wright attempted to establish a fire department-based ambulance service, and this resulted in many court battles with private ambulance services. The showdown eventually headed toward the California Supreme Court. (Courtesy of Gary Zikratch.)

Chief Wright changed the configuration of paramedic response from a squad concept to that of Advanced Life Support or Paramedic engines, with five engine companies strategically located throughout the city and two paramedics on each of the five engines. But a battle was soon brewing between ambulance provider Courtesy Ambulance and the San Bernardino Fire Department. Soon Courtesy Ambulance was bought out by American Medical Response (AMR). (Courtesy of Gary Zikratch.)

In 1997, Larry Pitzer began as the department's fire chief. Also enlisted from outside the department, Chief Pitzer was previously the operations chief for the Salem, Oregon, fire department, and he arrived just when the department was preparing to initiate its ambulance transport service. Eight ambulances were purchased by the city in anticipation of beginning fire-based emergency transport, but the program met its demise in 1998 when the California Supreme Court reversed an earlier appellate court decision and prohibited the department from providing Emergency Medical Service (EMS) transport. Because of the advent of standing orders for paramedics, Chief Pitzer changed the configuration of two paramedics on five engines to one paramedic on all eleven companies. Firefighter-paramedics Steve Brown (left) and Jeff English are pictured here standing next to one of the ambulances. (Courtesy of Bill Beaumont.)

Chief Pitzer began an aggressive program to replace the deteriorating fleet of fire apparatus. The department broke a long-standing tradition of only purchasing Seagrave or American La France fire apparatus and switched to Pierce fire apparatus. Eight new Pierce engines and a Pierce all-steer 100-foot aerial ladder truck were purchased. The obsolete, military-type water tender fleet was also phased out and three new Pierce brush engines were purchased.

In 1998, all aircraft rescue and firefighting responsibilities shifted to the San Bernardino Fire Department upon the closure of Norton Air Base.

The airport authority purchased a new crash foam rig and a cadre of department personnel were trained and certified as Aircraft Rescue Fire Fighting personnel.

Five
RESTORATION 1997 TO THE FUTURE

In 1982, the old 1890 hose wagon (pictured on page 33) was discovered, and looked like it had been exposed to the elements since the fire department sold it in the 1920s. A restoration project was begun, but it stalled after several years and the parts put in storage. In 1996, the wagon was moved to the Pioneer Fire Museum in San Bernardino where the restoration was completed.

The author (left) and museum co-founder Allen Bone put a few finishing touches on the front axle assembly. Bone is a firefighter for the Garden Grove Fire Department but grew up in San Bernardino and shares the desire to preserve its history. The display cabinet in the background came from a very old jewelry store in San Bernardino and was used to display artifacts from many fire departments in the area.

Vic Fisher, Allen Bone's uncle and a skilled craftsman, spearheaded the restoration project. His dedication to the project in the last few years of his life was invaluable in its completion.

Pinstriping and goldleaf specialist "Lil" Louie puts on a few finishing touches. The wagon had been lettered differently at least three times between 1890 and 1920. With the help of photographs, and Louies' expertise the wagon was made to look exactly as it did in 1896.

In December 1996, horses were once again harnessed to the wagon. Pictured here are Allen Bone (back), the author (front, right), and horse owner and driver Dale Thorough, who is also a firefighter for the City of Los Angeles.

Vic Fisher and his Dalmatian get the "chief's seat" for the 1997 Tournament of Roses Parade. The hose wagon has participated in two other Rose Parades since then.

Along with a Reno steam pumper, a San Luis Obispo chemical wagon, and a Fresno ladder truck, the San Bernardino hose wagon represented the California State Firefighters Association in the Tournament of Roses Parade.

In pretty rough shape, San Bernardino's old hose cart "Pioneer #2" (pictured on page 11) was found in 1978 by U.S. Forest Service firefighter Bud Parrott.

The hose cart was brought to the Pioneer Fire Museum and restored to its original condition through a partnership between Allen Bone, Mark Ostoich, Bud Parrott, and the author.

The original bell and nameplate for San Bernardino's hose cart "Pioneer #1" (pictured on page 11) were salvaged from a fire at the Society of California Pioneers log cabin when it burned in 1972. These items were located a few years ago and a plan is in the works to use them in conjunction with a "plain" hose cart from that era and duplicate the ornate ironwork.

The hose wagon and hose cart are shown here being decorated for the 2001 Tournament of Roses Parade.

124

Members of the San Bernardino Fire Department wore these early badges. They represent, from left to right, the Alert Hook and Ladder Company, a steamer engineer, and the assistant foreman of the Hose Company.

Members of the Deluge #2 Hose Company wore these badges. The officers wore the one on the right at membership meetings.

125

This is an example of the fire alarm equipment used in the station. When an alarm box was pulled, the oak-cased "house" gong on the left would ring out the box number. The indicator on the right would show the box number, and the repeater in the center would ring the large bell on top of the station with the particular box location to summon the volunteers.

In the early days, speaking trumpets were used as megaphones through which the foremen and chiefs would shout orders. Ornate silver trumpets like the one in the center were used as presentation items at such events as promotions and retirements. The symbol of the speaking trumpet is still used today to designate the ranks of different officers.

126

Early helmets were made of leather, but fancy helmets like these were made to wear only at parades and other celebrations. They are lightweight and are more ornate than "working" helmets.

There were also many different types of lanterns. On page 49, the hose wagon here is shown with the "Eclipse" lantern, above left. Railroad conductors also used the "Chiefs" lantern on the right.

San Bernardino City Fire Stations

Station #1	In 1866, located at Third and Arrowhead Streets. On March 24, 1907, relocated to Fourth Street near D Street. In 1952, relocated to 456 North Mt. View Avenue. In 1982, relocated to 200 East Third Street.
Station #2	In the 1880s, located at Ninth and F Streets and called the "Deluge Hose Company." In 1921, relocated to L Street near Seventh Street. In 1926, relocated to 900 block of North Mt. Vernon Street. In 1963, relocated to current location at 1201 West Ninth Street.
Station #3	In 1926, located in the 200 block of South Mt. Vernon Avenue. In 1975, relocated to current location at 2121 Medical Center Drive.
Station #4	In 1926, original station was built on the same location as the current station in the 2700 block of North E Street. The station was replaced in 1964.
Station #5	In 1941, located at Eleventh and E Streets. In 1964, relocated to Base Line and H Streets. In 1975, relocated to current location at 1640 Kendall Drive.
Station #6	In 1947, located at Gilbert and Waterman Avenues. In 1975, relocated to 1920 Del Rosa Avenue.
Station #7	In 1953, located at Fortieth and Electric Streets.
Station #8	In 1958, located in the 3800 block of Harrison Street. In 1975, relocated to the corner of Highland and Orange Streets.
Station #9	In 1960, located in the 200 Block of Meridian Avenue.
Station #10	In 1964, located at Mill and Arrowhead Streets.
Station #11	In 1964, located at Highland and Orange Streets. In 1988, relocated to 450 Vanderbilt Way.
Station #12	In 1998, located at 165 South Leland Norton Way, received from San Bernardino International Airport Authority.